THE ARTIST'S
HANDBOOK
OF BOTANY

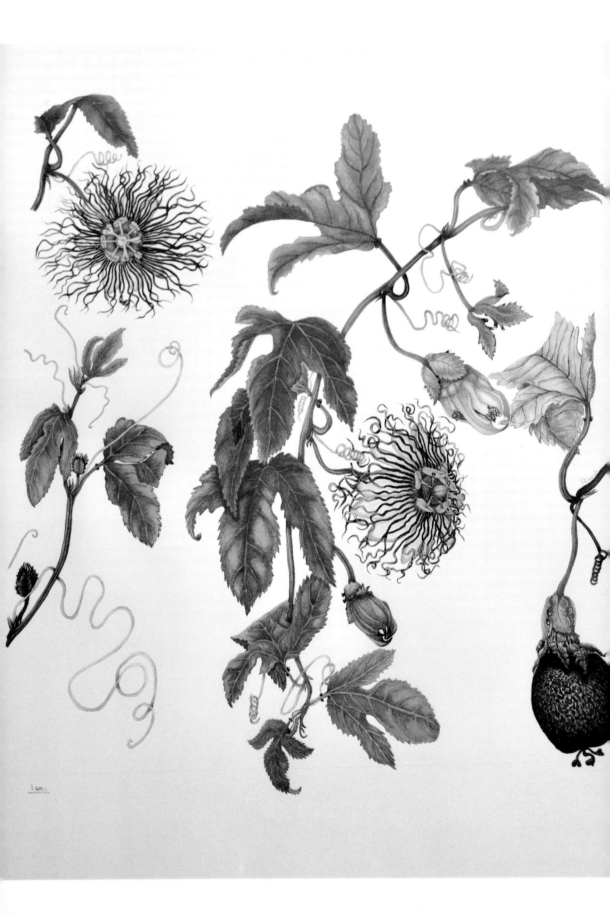

1 cm.

Lizabeth Leech

THE ARTIST'S
HANDBOOK
OF BOTANY

✳ THE CROWOOD PRESS

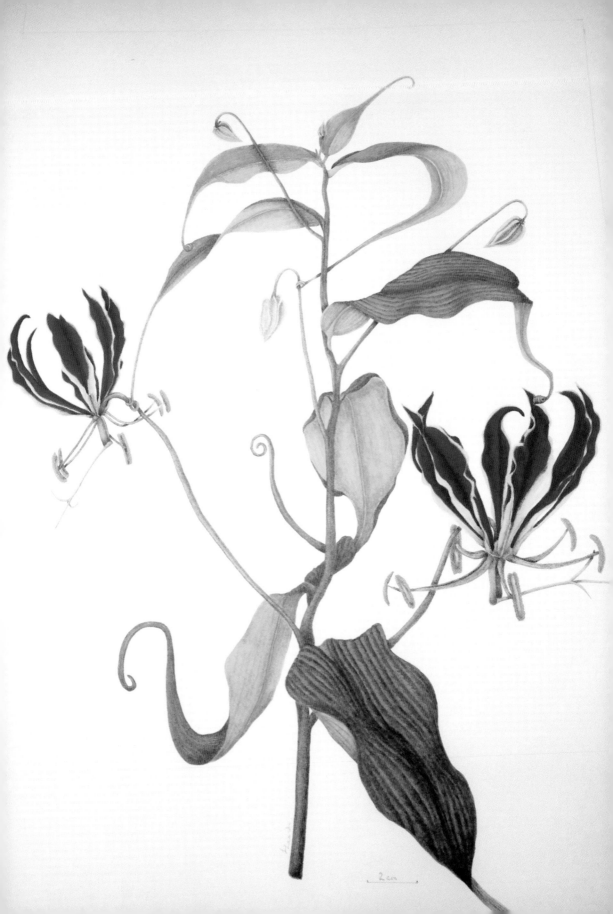

2 cm

CONTENTS

Left: Lizabeth Leech: *Gloriosa superba*.

INTRODUCTION

This book is intended to flag up all the most important diagnostic features of various plant groups, which anyone interested in recognising or painting plants should observe before trying to identify a plant or to paint a 'believable' picture.

Botanical art's main purpose throughout history has been to aid accurate identification of a plant species, as well as presenting a pleasing picture, for medicinal or culinary purposes. In times gone by, you could so easily poison yourself and your family when foraging or making herbal medicines without accurate observation and knowledge. In contrast, 'flower paintings' have only a decorative or an aesthetic use.

Knowing what is an important feature of a plant and why it has evolved also involves understanding its particular environment, its methods for ensuring successful reproduction (both sexual and asexual), and its success and survival. This is particularly pertinent in these times of obvious climate change.

Before painting or identifying a plant, I always recommend that you use the web or library to read a 'flora description' of a plant or its family in order to have an accurate shorthand account of its main features. Also, look up the particular species and variety of the plant to ensure that the plant you are painting has not been mislabelled – this often happens during repotting!

With the improvement and accessibility of phone cameras, you can easily record the main and less obvious features of a plant (for example the stem joints – nodes – where leaves arise) for future reference when identifying it or painting it accurately. These features should also be included in your sketchbook. They serve as memory joggers, and provide clear details to work from after the plant has died or is no longer available.

This book guides you through the main diagnostic features to observe and to include in your paintings. I hope this knowledge will underpin your work and will enhance your enjoyment of painting the full range of very beautiful and remarkable plants.

Lizabeth (Liz) Leech

Left: Lizabeth Leech: *Clematis*.

FLOWERS
(THE ANGIOSPERMS)

Any artist wanting to illustrate and paint flowers botanically needs to understand the structure of flowers and the arrangements of their parts. It is also helpful to understand how the structure of a flower relates to function in terms of attracting pollinators, or ensuring that pollen is carried by other means such as the wind; and how structure relates to function in terms of a plant's fruit development and its strategies for spreading (dispersing) its seeds. For these reasons I have included details of various flower parts and types for you to base your observations on. I have also included some basic biology to provide context to help you understand your subjects.

Flowers are produced by the group of plants called the *Angiosperms,* which means that they enclose their seeds in an ovary, unlike all other groups of plants. Flowers come in all shapes and sizes and colours, and have each developed solely for the purpose of carrying out successful *sexual reproduction*. This ensures that their genes (carried on their DNA) are mixed with the genes of another plant so that genetic variation occurs. This variation is very important to ensure that some of the offspring (that grow from seeds) can cope optimally with any changes in the environment, and can evolve.

All the different types of flowering plants have evolved in such a way as to ensure that their

Ophrys speculum, mirror orchid.

Portulaca flowers.

Left: Beth Phillip: *Dillenia suffruticosa.*

pollen grains (equivalent to animal sperm), which carry the male chromosomes successfully, meet and join with a plant's egg cell, carried in an ovule (equivalent to the egg cell of an animal) in its ovary. This meeting of male and female DNA ensures successful sexual reproduction, which *fertilises* the egg cell and ensures the development of a seed.

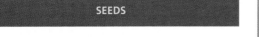

SEEDS

Seeds have tough seed coats and are resilient in order to protect the dormant 'baby plant' and its food store until good growing conditions occur – for example after a drought, or in the warmer spring. Many seeds and the fruits that contain them are also an important food source for animals and humans due to the food stores they contain.

Insect-pollinated flowers

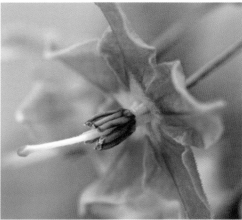

Potato vine, *Solanum laxum*, flower.

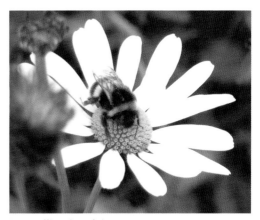

Bee pollinating daisy.

POLLINATION

Pollination is the transfer of pollen from the anther to a stigma. As plants are anchored to the ground, they have to rely on either insects, or other animals, or the wind to transfer pollen from one flower to another. Insect- and wind-pollinated flowers look very different.

Insect-pollinated flowers are usually showy, brightly coloured and often scented, have guidelines, and may have nectaries; these are all features designed to attract the right insects or animals that will transfer their pollen from one plant to another of the same species. It is important that all these features are shown.

Wind-pollinated flowers are often small and drab, and have smaller or reduced parts. The male anthers dangle outside the flower so the released pollen is caught and transferred by the wind. The female stigmas also protrude to catch passing pollen grains. Look out for these in a mature flower and illustrate them.

Wind-pollinated flowers

Hazel male catkins with reduced flowers and obvious anthers.

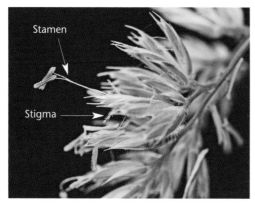

Cocksfoot grass flowers with protruding stamens and long wobbly anthers. The stigmas are white and net-like to catch pollen.

The Four Main Whorls of Parts in a Typical Flower

How flowers look, and the arrangement and shape of their flower parts, is very important and specific for each species of plant, depending on how their pollen is transferred (called *pollination*) and how the male DNA reaches the

egg cell (*fertilisation*). It also depends on how the resulting fruits and seeds are dispersed, whether by animals, wind or water.

When examining a flower, it is useful to record what you see in a sketchbook. This helps you to remember where the parts are attached when you are starting to draw or paint the plant – possibly once the plant has died!

Flower parts consist of four main rings or whorls of parts – the sepals, the petals, the stamens (male parts) and the carpels (female parts). These parts arise from the flower stalk (the pedicel), from its free end, which broadens to form the receptacle (from which all the flower parts arise).

> **THE IMPORTANCE OF FLOWERS IN PLANT IDENTIFICATION**
>
> Every plant species is unique in the arrangement and number of flower parts in each whorl, which helps identification – many angiosperm plants are impossible to recognise and identify in the field without a flower. DNA testing is still too impracticable outside a laboratory.

The Main Features of Each Whorl

The Outer Whorl of Sepals or the Calyx Collectively

Look at this outermost whorl by following the flower stalk upwards, and look at the underneath of the flower for the first layer, or the outside layer of a bud.

Sepals may be green, smooth, or hairy or coloured, like the petals, or even identical to the petals. They protect the other flower parts

The calyx of sepals

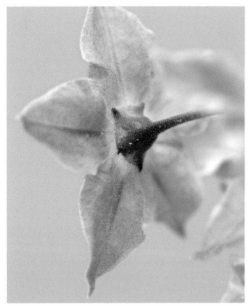

Potato vine flower with five united sepals.

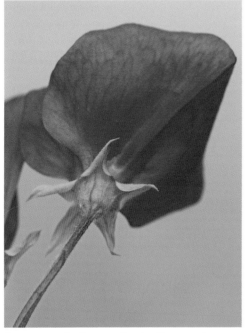

Sweet pea, *Lathyrus odorata*, five sepals united into a short tube, and then free.

before the bud opens. They may be separate – they will pull off individually – or joined for some or all of their length to form a sepal tube.

In some plants the sepals persist after the flower shrivels, or they are deciduous and drop off. Beware the sepals that drop off as the flower opens, for example the poppy. They will always leave scars on the receptacle if this is the case.

Looking for scars where flower parts have dropped off – for example in a poppy

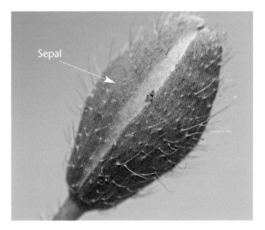

Poppy bud with sepals.

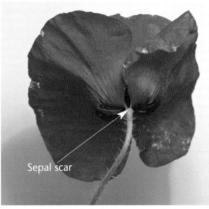

Poppy flower with the sepals missing.

The Whorl of Petals or the Corolla Collectively

This whorl is inside or above the whorl of sepals on the receptacle. The petals are designed to attract the appropriate pollinator animal to the flower, so that the pollinator picks up pollen or deposits the pollen from another flower. They may have different coloured guidelines leading the pollinator to the centre of the flower. They may also have a particular scent (pleasant or unpleasant, but attractive to a particular pollinator), or nectaries that produce sugary nectar to feed a particular pollinator as recompense for helping the flower.

The number, colour, size and arrangement of the petals is critical for accurate identification of the plant. The petals may be free and pull off the receptacle easily; they may overlap at the edges; or they may be joined together for part of their length, or all the way forming a tube of petals.

Guidelines and nectaries

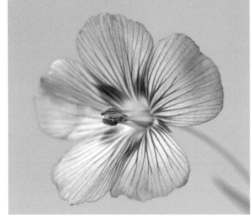

Flax showing guidelines on the petals.

PERIANTH AND TEPALS

The sepals and petals may often be indistinguishable from each other (apart from their position on the receptacle). In this case both whorls are called the perianth, and the parts may be called tepals. The sepals are petaloid when they are identical to the petals. The petals are called sepaloid when they are identical to the sepals.

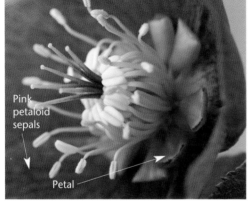

Hellebore flower: the petals are in the form of tubular nectaries; the sepals are petaloid.

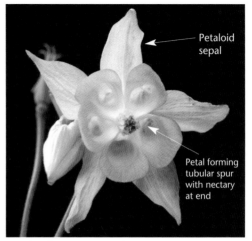

Tepals of *Aquilegia*, Columbine.

The Stamens or the Androecium Collectively

The stamens and the androecium are the male part of the flower and consist of a stalk called a filament, and the anthers, which make and shed the pollen.

Pollen grains carry the male DNA and are equivalent to animal sperm. Stamens may be in one, two or multiple whorls, depending on the flower type. The number of stamens in a flower also depends on the species of plant. If there are too many to count easily, they are called 'numerous'.

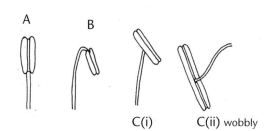

Anther attachments.

STAMENS IN DICOTYLEDONS AND MONOCOTYLEDONS

One, two, four or five or multiples of these numbers of stamens are found in dicotyledonous plants, and three or multiples of three stamens are found in monocotyledonous plants. This is also true of the other whorls of parts.

Variations in Anthers

Anthers are attached to different parts of the filament (stalk), and this is specific for each type of flower. Thus *basifixed* is with the stalk attached at the bottom of the anther (A). *Apicifixed* is with the stalk attached to the top of an anther (B). *Dorsifixed* is where the stalk is attached to the centre back of the anther (C).

Anthers may face into the centre of the flower, or outwards towards the petals. This is also specific to each plant.

How the ripe anthers open to shed pollen is characteristic of each type of plant. The centre of each ripe pollen sac ruptures along a line of weakness from the tip to the base, or diagnostically, as in the Ericaceae (such as heathers,

rhododendrons); they open by means of a pore (hole) near the top of the pollen sacs.

Some flowers lose their anthers or stamens after they have ripened, and some have persistent anthers or stamens. In some flowers where the stamens are sterile no proper anthers develop.

The Carpels or the Gynoecium

The carpels and the gynoecium are the units of female parts of the plant, and arise from the centre of the flower stalk receptacle. They contain the female egg cell in a structure called the ovule, which later develops into a seed if the egg has been fertilised by the pollen DNA. Carpels may be single or joined at their bases, or united.

A carpel consists of three main parts:

* The *ovary*, which contains the ovule(s), protects them, and finally, after successful reproduction, helps to disperse the seeds once they are ripe.
* The *style* (or pistil in older books), which positions the pollen collecting surface in the right place to pick up pollen grains from the insect or the wind – depending on the flower's pollination method.
* The *stigma*, which collects pollen grains at pollination. The surface is rough or sticky so the pollen grains adhere to it. It also produces

a cocktail of sugars that are specific to that species of flower. This 'cocktail' stops alien pollen grains growing, if they are not from the same species of plant. If they are from the same species, a pollen tube grows out and through the style to the ovary where it is attracted to and penetrates an ovule. The male pollen DNA moves down this pollen tube and into the ovule's egg cell for fertilisation, after which the ovule develops into a seed.

Parts of a carpel

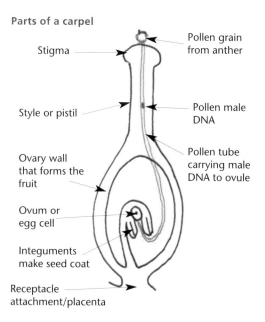

Stigma

Pollen grain from anther

Style or pistil

Pollen male DNA

Ovary wall that forms the fruit

Pollen tube carrying male DNA to ovule

Ovum or egg cell

Integuments make seed coat

Receptacle attachment/placenta

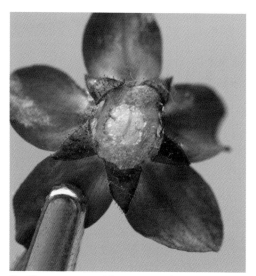

Saxifrage ovary with two carpels.

If you cut half flowers or across the ovary, it is important to note how and where the ovules are attached to the ovary, and any obvious divisions (septae) between the ovaries. This, too, is diagnostic for each species – its placentation (just like a baby in the womb) is its attachment that brings food and so on to the developing seed.

You will need this information if you draw a floral diagram or a half flower picture.

THE NUMBER OF CARPELS

How do you know how many carpels there are in flowers with fused carpels? Count the number of styles or stigmas in your flower. Cut across (transversely) the ovary, and count the number of divisions with ovules or seeds in them. This number is the number of carpels making up the ovary.

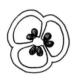

AXILE (TS)

PARIETAL (TS)

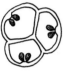

PARIETAL (TS)

FREE CENTRAL (TS)

MARGINAL (TS)

APICAL (LS)

BASAL (LS)

TS = TRANSVERSE
(CROSSWISE) SECTION

LS = LONGITUDINAL
(LENGTHWISE) SECTION

Placentation.

Axile placentation is where the ovules are attached to the central axis of the ovary where the septa connect, e.g. citrus, aloes, hibiscus.

Parietal placentation is where the ovules are attached to the middle (centre) of the wall of the carpel, e.g. in begonia.

Free central placentation found in the carnation family (Caryophyllaceae), e.g. carnations and pinks, and the primrose family (Primulaceae), e.g. cyclamen, primula. Here the central column or axis of tissue does not extend to the top of the ovary wall and is therefore 'free'. The ovules are distributed all over this.

Marginal placentation is where the ovules are attached to the edges of the carpels, i.e. where the walls of two carpels join, e.g. in the pods of peas and beans.

Apical placentation is where the ovules arise from the upper edge of the single-chambered ovary, e.g. *Morus* (mulberry) and *Ficus* (fig).

Basal placentation is where the ovules arise from the base of the single space in the single-chambered ovary (*unilocular*), e.g. *Berberis, Rumex*.

When observing a flower, the artist needs to note where the ovaries occur in relation to where the other whorls of parts arise from the receptacle (flower stalk) – that is, the position of the ovary. All flowers in a family have similar ovary configurations in relation to the receptacle and the other whorls of flower parts.

Ovaries in Relation to the Other Whorls of the Flower

There are inferior and superior ovaries in a flower: *inferior* ovaries often look like a swelling at the top of the flower stalk (below the sepals) and may be missed. The receptacle grows round the ovary and is fused to its walls: therefore the sepal, petal and stamen whorls are called *epigynous* and seem to arise from the top of the ovary with the style coming through the centre of the stamens – for example, daffodil.

Superior ovaries arise from the top of the

receptacle, in the centre of the other three whorls of flower parts. The other flower parts are called *hypogynous* – they arise from below the ovary.

In some flowers with superior ovaries the parts of the receptacle bearing the sepals, petals and stamens extend upwards like a vase or are very close to the ovary (as in an apple) so these parts look higher than the ovary. In these cases they are called *perigynous*. In false fruits such as apples and pears this means there is a small hole in the centre of the flower through which the style and stigmas protrude. This hole is surrounded by persistent sepals, and is at the opposite end of a pear/apple to the stalk.

Superior ovary

Receptacle

Epigynous flower parts

Inferior ovary

Superior ovary iii

Extended receptacle or hypanthium with perigynous flower parts

Types and positions of ovaries.

Rhododendron Loderi
'Game Chick' June 2021

× 1

× 14/15/16
Stamens.

× 1

all
× 1

× 1

× 1

Seeds
Oct 2021

× 1
July 2021

← change
angle

open
wood

× 1
full flower
corolla with
seven lobes

seeds
Oct 2021

open
wood

× 1

HALF FLOWER DIAGRAMS, FLORAL FORMULAE AND FLORAL DIAGRAMS

RECORDING FLOWER STRUCTURE

There are several ways of recording flower structure. The simplest way is to just draw the flower and hope that it looks correct. However, this is not advisable as you need to look at how many parts there are in each whorl, their arrangement in relation to other whorls, and how they are attached to the receptacle and/or themselves or to other whorls. This can be recorded in a sketchbook as a work sheet.

The three methods, which will be described below, also help you to understand the flower so your final drawing/painting will be correct. I would always construct them as I look at a flower for the first time to concentrate my mind and to give me a better understanding of the number of parts and how they interrelate.

Each of these three methods gives a different 'view' of the flower parts and their relationships so that you can build a three-dimensional 'picture' of the whole once you learn how to interpret them. They represent a botanist's shorthand descriptions of a specific flower, and each method has its own simple conventions.

These methods are very useful for botanical artists to refer to when finally drawing a flower, to make sure the parts are in the right place and

that you understand the flower structure. They also help you to understand the similarities of flower structure in each plant family.

However, *each method on its own* has its limitations, and so it is best to have all three recorded in your notes. You can also search for them on the internet when you look up a flora description of the genus, or a species of a plant or its family – though many are not readily available, nor are they always correct.

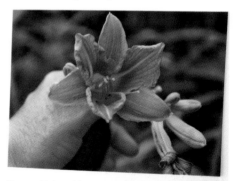

Penny Price, *Hemerocallis*, a painting study sheet.

Left: Leigh Ann Gale: Sketchbook page of *Rhododendron loderi* 'Game Chick'.

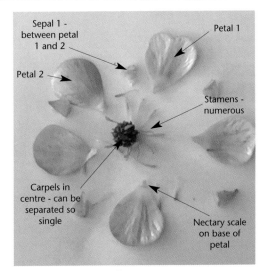

Penny Price: *Hemerocallis*, a field study sheet.

FLORAL FORMULAE, K C A G

This is a simple way of conveying the number of parts in each whorl and any other whorls of parts that they are attached to. It gives no idea of the spatial organisation between different whorls.

Step 1: Start by looking at your flower. Turn it over so you are looking at the underneath – that is, the sepals and where the flower stalk is attached.

Take your flower and pull off each of the sepals first – starting at the top of the flower, follow the side of the flower stalk up to the flower to find the top, usually in the centre of the upper petal – for example, buttercup. This is also the line you start your cut to get a half flower.

Note that in this case the sepals (reflexed or bent backwards) are between the petals.

Step 2: Pull off the sepals one by one and

Looking at a simple flower.

arrange them in a circle in the correct positions. Do this for all the four whorls of parts. (Note the buttercup petals overlap with the left side behind the next petal moving clockwise on the upper surface.) This arranging of the parts, as

you remove them, shows how the parts are arranged in relation to other whorls.

To write the floral formula: count the parts in each whorl and see if they can pull off singly (as in a buttercup) or if they are attached to each other or to another type of flower part.

The sepals are represented by **K** (calyx), so **K5** means five single sepals. If the sepals are united then they would be **K(5)** with the brackets indicating they are united.

The petals are **C** represented by (corolla), so **C5** means five single petals. If petals are united then they would be **C(5)**.

The stamens are represented by **A** (androecium), so A∞ is infinite stamens or too many to count. A(∞) would mean that all stamens are united.

The carpels are represented by **G** (gynoecium), so G∞ is numerous single carpels. G(∞) would indicate united numerous carpels. G∞ with an underline means the carpels (ovaries) are superior – they arise above the other flower parts in the buttercup. An overline means the carpels (ovaries) are G∞ inferior – they arise from the flower stalk below the other flower parts.

If whorls of parts are joined then there would be a curved horizontal bracket from one whorl to the other – for example C5 A5, meaning the petals and stamens are united.

The floral formula for a buttercup is: K5 C5 A∞ G∞ – that is, five single sepals, five single petals, numerous stamens and numerous carpels.

In front of the floral formula the **symmetry** of the flower is indicated with either of the following symbols:
·|· In **bilateral symmetry**, the **zygomorphic** flower can only be cut along one plane to give two identical half flowers. *Salvia*, a bilaterally symmetrical flower, can only be cut from the top down to give two identical half flowers.

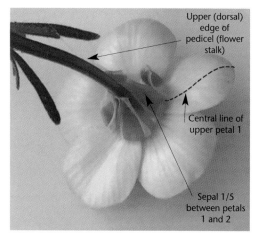

Upper (dorsal) edge of pedicel (flower stalk)

Central line of upper petal 1

Sepal 1/5 between petals 1 and 2

Looking at a simple flower, a buttercup.

Bilateral symmetry in a salvia

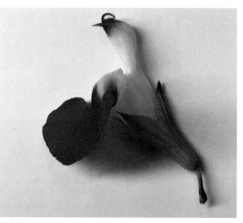

Salvia 'Hot Lips' flower from the side.

Salvia 'Hot Lips' from the front.

Or:

⊗ **Radial symmetry** – the **actinomorphic** flower can be cut in any plane to give an identical half flower.

⊗ ♂ **K5 C5 A α G**α

is the Buttercup floral formula.

Radial symmetry in the rock rose (*Helianthemum*) petals, but not if you look at the sepals

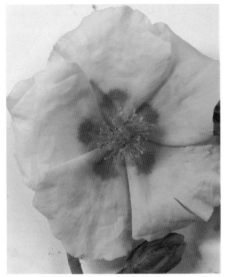

Rock rose petals from above the flower...

...and rock rose sepals from below the flower: three large and two smaller outer sepals.

Helianthemum has five petals, so each identical half flower cut would include two and a half petals. Note the petals are contorted or overlap on one side.

A symbol for the sexual parts are also included in the flower:

♂ fertile male stamens – flower male only.

♀ female carpels present in the flower – female flower only.

hermaphrodite flowers with fertile male and ♀ female parts.

⊗ ♂ **K2 +3 C5 A∞ G(3)**

is the full floral formula for a *Helianthemum* (rock rose).

FLORAL FORMULAE METHODS

The method I use for writing floral formulae is the standard traditional format. However, you may find less traditional examples and terminology – for example, Ca for calyx instead of K, and Co for corolla instead of C. Once you understand my method, you will be able to interpret all of them.

FLORAL DIAGRAMS

Floral diagrams give the numbers and spatial arrangements of each part in a whorl and make clear the arrangements and relationships between the parts of one whorl and the others.

The floral diagram goes hand-in-hand with the floral formula to give a two-dimensional short-hand view of the arrangement of the parts in each whorl.

Using the layout of the parts as you dissected the flower (*see* buttercup on page 21, and the

Axis (central line)

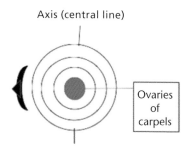

Ovaries
of
carpels

Showing the position of the bract.

diagrams of the transversely cut (TS) ovaries on page 16 to help you), draw three concentric rings with a compass. Each ring represents a different whorl. The outer ring is the sepals, and inside the innermost ring are the ovaries of the carpels – so leave enough space to draw them.

Now, determine the axis (central line) of the flower in relation to the ovaries TS drawing, and indicate it by an upright line at 12 o'clock and 6 o'clock outside the three circles.

Indicate the position of a bract below the flower, or at the point where the flower stalk branches from the main stem, by this infilled bracket symbol outside the three main whorl rings – in the correct position.

Starting on the outer calyx ring, insert the sepals in their correct position.

– Symbol for a sepal (simple bracket with no fill).

Then move to the next (corolla) ring and insert the petals in their correct position in relation to the sepal arrangement and the adjacent petals.

Symbol for a petal

Symbol for a petal with spur

Note: There are three basic types of orientation of flower parts in the two outer whorls (the calyx of sepals and the corolla of petals):

* Valvate – edge to edge.

* Contorted – overlapping like the tiles of a roof.

* Imbricate – overlapping with one or more parts inside and more outside, for example in a pea flower.

Then move inwards to the third (androecium) ring and insert the stamens in their correct arrangements in relation to the other parts. Note the direction in which the anthers open.

∞ Symbol for a stamen; symbol for a sterile stamen or staminode.

In the centre of the three rings, draw in a transverse section (TS) of the gynoecium of the ovary/ovaries (if united) so you can see the number of carpels with their arrangement and the placentation (point of attachment) of the ovules (*see* page 16).

LOOKING AT OVARIES

When cutting transversely (crosswise) through an ovary it is best to use one from a fading flower or a developing fruit where the ovary is already swelling. This will make the section easier to cut, see and understand.

Buttercup ovaries showing the attachment of the ovules to the receptacle. TS single-seeded separate ovaries of the carpels, attached to the central receptacle of the buttercup.

To complete the floral diagram where the parts of a whorl are linked – for example where the petals are united – the symbols are linked together with a curved line.

You would do the same for the sepals if they were united.

If the stamens are attached to the petals or sepals, the symbols would be connected by a straight line. e.g.

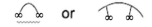

stamen filament (stalk) attached to petal.

If the anthers (pollen boxes) are attached to each other, they would be linked by a curved line:

where the stamens' filaments are united.

If an extension of the receptacle forming a floral cup/tube, called a hypanthium (*see* page 17), is present, and the three outer whorls are attached to this, then insert a shaded double ring symbol between the inner ring of stamens and the central gynoecium.

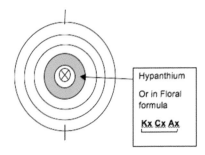

Hypanthium

Or in Floral formula

Kx Cx Ax

Floral diagram and half flower diagram of buttercup.

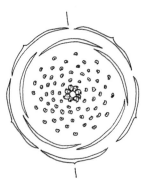

Floral diagram of buttercup. The anthers open inwards.

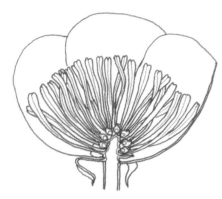

Half flower drawing of buttercup.

Working out the floral formula and floral diagram of heather

View of the petals – four united.

View of the sepals – four united; the sepals are positioned where the petals join (unite) to form a tube.

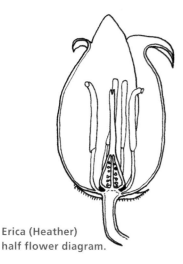

Erica (Heather)
half flower diagram.

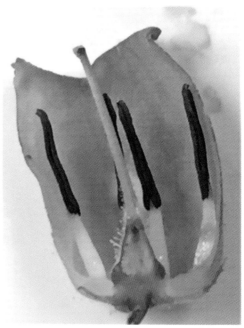

Half flower showing the positions of the stamens – eight in two whorls of four – and the superior ovary with the long style and stigma, and nectaries as green swellings at its base.

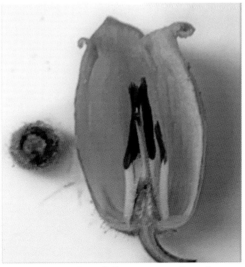

Transverse section of the ovary to show four chambers, and the LS ovary in the half flower of Heather.

Working out the floral formula and floral diagram for mallow

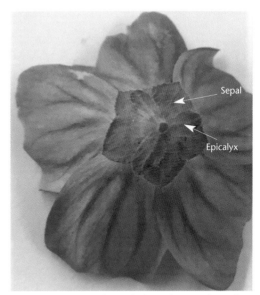

Sepal

Epicalyx

Showing the epicalyx – below the sepals – of three; and five sepals positioned between the petals Mallow.

$$ \text{⊗ ♂ } K_{(4)} \, C_{(4)} \, A_{4+4} \, G_{\underline{(4)}} $$

Floral formula of Heather.

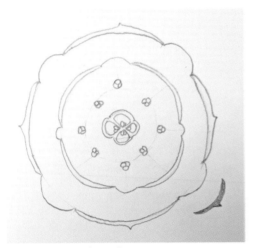

Floral diagram of Heather.

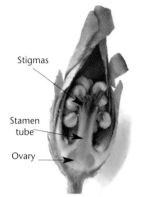

Stigmas

Stamen tube

Ovary

Mallow half bud showing the positions of the other parts, with the stamen tube (surrounding the ovary, and the style) arising from the petals. The ovaries are to the side of the style.

The ring of ovaries cut across to show the developing five schizocarp fruits, which split into ten when they are ripe around the receptacle (below the five styles).

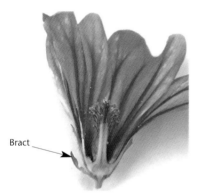

Bract

Mallow half flower. The anthers have shed their pollen, so are less clear, while the contorted pattern of the petal overlap is more obvious.

$$\oplus \ \male\female \ \text{epi} K\,3 + K_{(5)} \ \overparen{C_{(5)}} \ A_{10} \ G_{\underline{(5)}}$$

Floral formula mallow.

Older, developing ovaries (the other flower parts have dropped off) surrounding the receptacle; the ovaries are in a ring with the persistent sepals attached. Mallow with developing fruits.

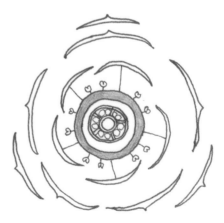

Floral diagram mallow with the epicalyx plus the calyx; and the hypanthium round female parts, to which the stamens are attached around the styles.

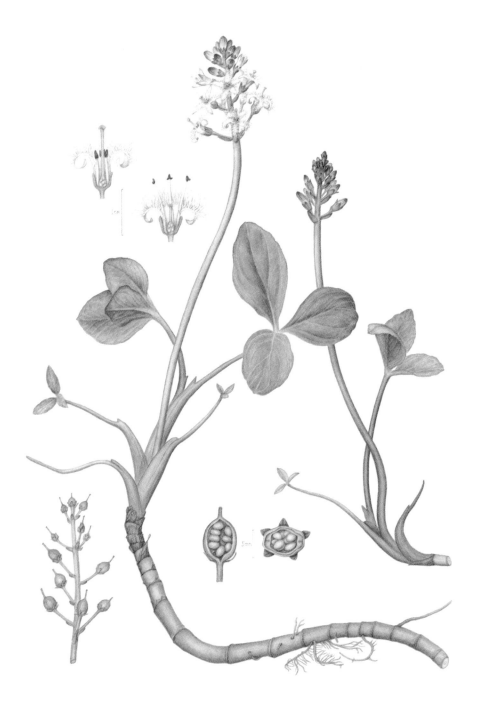

Linda Pitkin: *Menyanthes trifoliata*, bogbean.

The spur section is good, but the ovary has burst to show the developing seeds attached in two rows near the walls of the ovary; the style and stigma are removed.

Attempting to cut a half flower of *Viola*, pansy

The petals cut, but the bottom spur (not halved to show the stamen attachment) and ovary still intact.

HALF FLOWER DIAGRAMS

Half flower diagrams are valuable as they show you how and where the main floral parts are attached to the receptacle and to each other, and their relationship. They also show the proportional sizes and shapes of the various parts within the flower.

The half flower diagram should look like the flower being illustrated, and should make obvious how the various parts and structures are situated, and how they operate to make sure that successful pollination occurs by ensuring that the appropriate pollinators – whether insect or bird – are attracted or lured (by nectar) to where they pick up pollen from the ripe anthers and deposit it on the ripe stigmas.

The flower is cut longitudinally (from the stalk to the top of the flower) through the plane of symmetry that passes through the main axis – marked on your floral diagram.

Too much of the spur is removed, but the lower anther attachment and the nectary are more obvious. The female parts are still all intact.

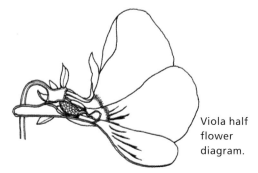

Viola half flower diagram.

Alstromeria half flower drawing in stages

Step 1: Choose a typical flower on your plant. Don't be tempted to choose one that is slightly different and aberrant compared to the rest. (You may also want a bud to cut and refer to, and an older flower where the anthers and stigma are ripe as in the Mallow section.)

To get details of the carpels and their ovaries, choose a dying or an old flower to have a clear

idea of the positions and attachments of the developing ovules (seeds).

Locate the flower's axis line of symmetry. Lay the flower on a cutting board or a white ceramic tile, and using a new scalpel blade or single-edged razor blade, cut along the axis from the stalk to the top of the flower. This is not as easy as it sounds, and it may need several tries to get a good half flower. Often one half is better than the other, so use this – or a combination of all tries!

Alstromeria 'Indian Summer' flower

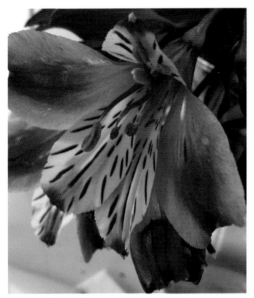

Although the flower parts are evenly numbered, the flower is not radially symmetrical due to how they are distributed. They are bilaterally symmetrical – they can only be cut in half on one plane of symmetry.

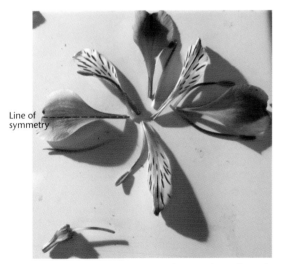

Line of symmetry

The arrangement of perianth parts (petals and sepals).

Step 2: Start by drawing an enlarged, longitudinal section through the ovary, putting in the ovules attached to their placentas, the dividing walls (septa) of the ovary (if the carpels are united) and the attachment of the ovary to the receptacle (the tip of the stem).

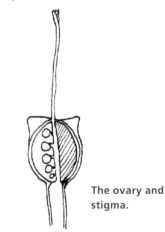

The ovary and stigma.

Step 3: The other flower parts should be the correct size proportionally when you draw them in. Starting large means that you will be able to fit all the parts into your half flower!

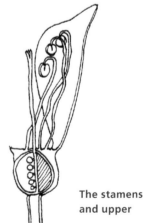

The stamens and upper

Step 4: Cut parts should be drawn with thin double or parallel lines (in publications you may see cut surfaces depicted using a thick dark line). Using two lines is an accepted convention, or one thicker line. Uncut parts are drawn with single thin lines.

Step 5: Make sure that all lines connect properly and that you have no lines ending in space. Every connection of the flower parts to the receptacle and to each other should be clearly visible – this is why you need to understand the flower completely before attempting to draw a half flower.

Step 6: The half flower can be drawn in graphite without any shading for clarity, or in ink, and annotated for a scientific floral diagram; or you can paint it once it is drawn. (Make sure you don't lose the clarity of the connections if you paint the half flower – see Everlasting Pea drawing on page 33.)

The complete half flower.

Alstromeria

⟶ axis of symmetry.

Cross-section ovary

Completed half-flower longitudinal section

† ⚥ $P_{3+3} A_6 G(\overline{3})$

style 1 with 3 lobed stigma (when ripe)
fruit a capsule

↑ axis

Half-flower diagram related to floral formulae and floral diagram.

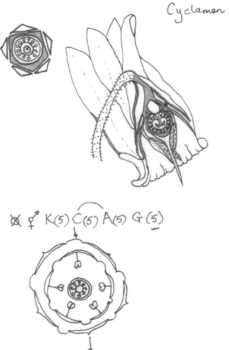

Cyclamen

⚥ $K(5) C(5) A(5) G(5)$

Half *Cyclamen hederifolium* flower drawing in graphite, floral formula and floral diagram.

In some cases, with really complex flowers, it may be better and more explanatory to draw the whole flower/plant and then a series of graphite drawings or paintings as the outer layers are removed as in the Polygala painting on page 33.

Lycium barbarum.

Duke of Argyll's Tea Tree

Graphite and watercolour of *Lycium barbarum*, Duke of Argyll's tea tree, including half flower and half berry fruit. *Lycium barbarum* is related to the potato and goji berry. It is found on sand-dune systems. In this case a habit drawing shows the shrub's untidy, tangled growth and has a separate scale bar to indicate its size.

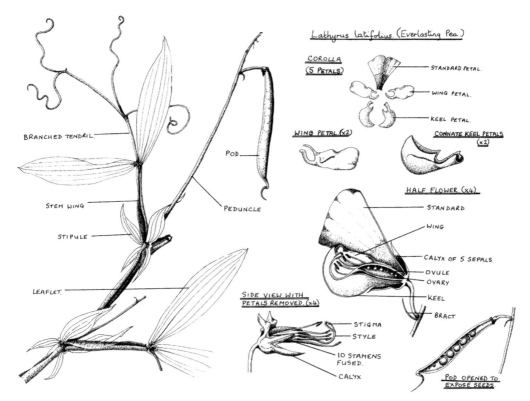

Annotated scientific drawings of everlasting pea, *Lathyrus latifolius.*

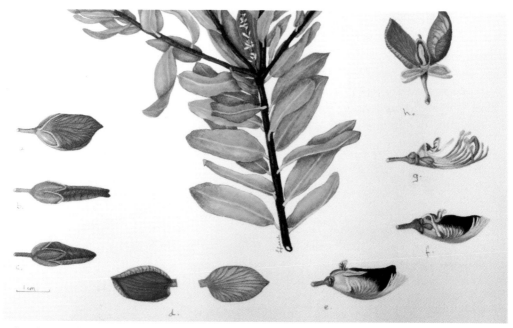

Polygala myrtifolia var. grandiflora detail, from a botanical painting.

Polygala Detail painting - an explanation

The bud is illustrated from the side, from above and from below (a–c) to show the distribution of the first whorl (outer) of the sepals and inner petaloid sepals; (d) the inner two petaloid sepals removed; (e) the remains of the flower after the two inner sepals are removed; (f) the petals on one side removed so the ovary is shown near the base of the flower; (g) the keel petals removed showing the stamen arrangements and the ovary, style and stigma and the two remaining petals on the far side; (h) the remains of the dying flower with persistent sepals (both sepaloid and petaloid) and developing ovary (fruit).

Drawings or paintings of flower parts can enhance your final painting and help the onlooker to understand the flower structure, as well as the pollination method by its pollinator.

In summary, closely observing flowers by means of constructing floral formulae, floral diagrams and half flower diagrams helps the artist to understand their subject prior to painting the flower, and leads to more detailed, believable and accurate paintings. The whole process is worth the effort, and prevents one having those moments where you can't remember exactly how the flower looked or how the parts are connected – leading to unbelievable paintings that jar on the observer and are less than satisfactory.

Flower of the rat-tailed radish, *Raphanus caudatus*

The diagrams show the flowers and the arrangement of the removed sepals, petals and stamens. The two short stamens by the N–S sepals are not easily visible in the flower picture.

In this case the flower was too delicate to cut a half flower as the sepals and petals drop off easily when disturbed, so the forward two petals, the forward sepal and a stamen were removed to give an idea of the half flower arrangement. The three methods of observational recording give a strong reminder of the flower structure for easy reference.

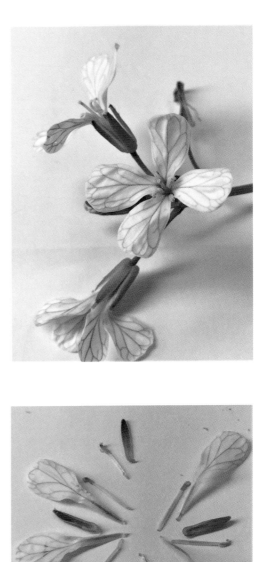

Rat-tailed radish half flower and floral formula, floral diagram and half flower drawing

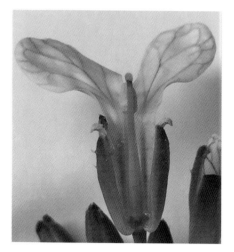

Rat-tailed radish ovary

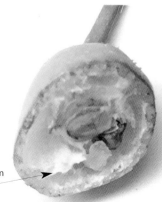

Membranous septum dividing 2 carpelled ovary in T.S.

Membranous septum separating 2 carpels longitudinally L.S. ovary

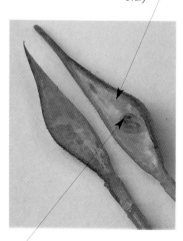

Hole in membranous septum showing developing seed behind

Rat-tailed Radish.

⊠ ♂ K₄C₄A₆G(2)

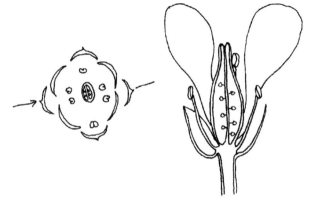

Lamiaceae family, for example Salvia

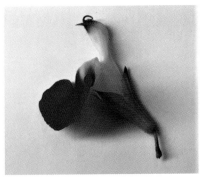

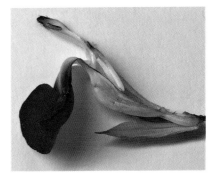

Salvia *'Hot Lips'* flower. Five united petals. The upper hooded petal covers the style, and the bifurcate stigmas protrude when ripe; the anthers open downwards. The lower red lip petals form a landing site for the insect pollinator, such as a bee.

A view of both stamens with the filaments united (uncut) where they form the projecting counter balance. This shows how the shape and distribution, and the siting of the flower parts, are designed to ensure successful pollination, so the flower sets seed to give the next generation.

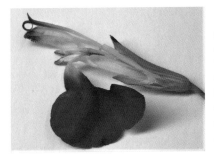

Stamen joined to the petal tube of the side petals, with a backward-projecting balance mechanism. The weight on the lower lip pulls on the stamen, which rocks down so the anthers touch the bee's back, depositing pollen. The ripe stigmas also move downwards and will pick up pollen from the back of a bee that is already carrying pollen from another flower.

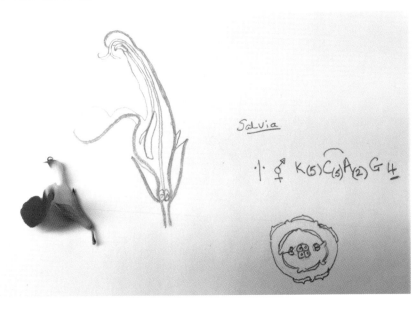

Salvia

$\cdot | \cdot \ \male\female \ K_{(5)} C_{(5)} A_{(2)} G \underline{4}$

Michaelmas daisy floral formulae and floral diagrams of florets

MICHAELMAS DAISY

⊗ ♂♀ K pappus C(5) A(5) G(2̄)

disc floret in centre of inflorescence (capitulum)

anthers united in a ring round style

·|· ♀ K pappus C(5) A₀ G(2̄)

ray floret round outside of inflorescence.

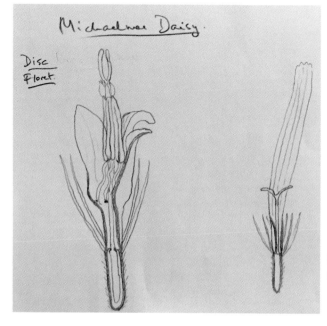

Michaelmas Daisy.

Disc Floret.

Half flowers of Michaelmas daisy florets.

The Asteraceae family, with a head of flowers

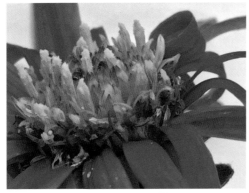

Showing the outer purple ray florets and central, yellow disc florets.

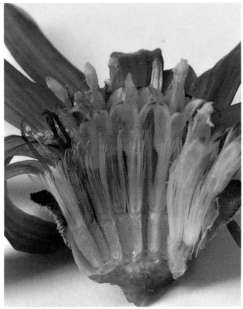

Inflorescence cut in half to show the attachment of the florets to the flattened receptacle.

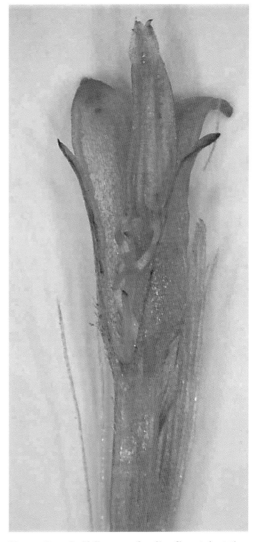

Not quite a half flower of a disc floret, but the picture shows the bendy long stamen filaments (to allow for the flower growing as it opens) and the ring of anthers round the style. The stigmas have not emerged through the top centre yet as it ripens after the pollen is shed, to prevent self-fertilisation. Five petals are united to form a tube, and the sepals are reduced to a ring (pappus) of hairs attached to the top of the inferior ovary, for fruit dispersal.

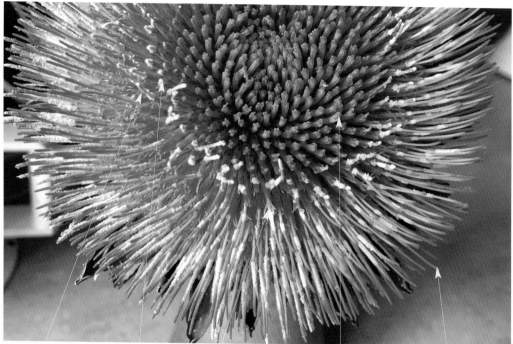

Purple style extending through anther tube (white) as flower matures

Ring of white anthers emerging from petal tube as style extends. Anthers releasing white pollen grains

Showing tips of petal tube extended (fully open) of mature flower

Immature, unopened disc floret (flower) with petal tube with five curled over free ends indicating five petals

Extended style and stigma at end ready to collect pollen from bee. Floret mature. White ring of anthers now looks half way along mature style

Half a Composite Head or Inflorescence of Artichoke, showing development of disc florets (no ray florets present)

TYPES OF INFLORESCENCES AND FRUITS

INFLORESCENCES

Inflorescences are groups of more than one flower on a stalk called a peduncle. The arrangements of the flowers on the flowering stalk form different types of inflorescence, and the numbered diagrams indicate the order that the flowers, in each case, open – one (first), two (second) and so on. This order of opening can make or break an excellent picture, so you need to make sure it is correctly depicted.

Raceme.

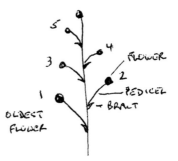

Raceme

A raceme is an inflorescence with a strong, upright stem with single-stalked flowers arising from the axil of a leaf-like bract.

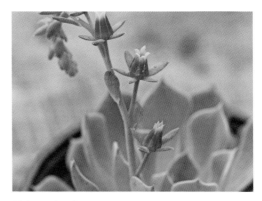

Echeveria elegans.

Left: Penny Price, *Lupin* 'The Governor'.

Panicle or Branched Raceme

A panicle or branched raceme is an inflorescence in which the axils of the bracts give rise to further racemes.

Panicle.

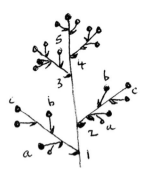

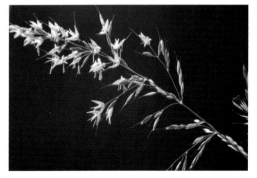

Arrhenatherum, **false oat grass panicles.**

Spikes

Spikes are inflorescences where the flowers lack stalks and are attached directly to the peduncle (inflorescence stalk).

Spike.

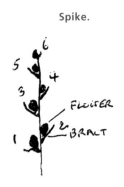

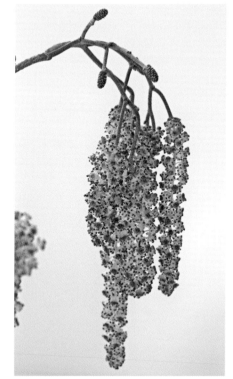

Alder catkins with modified male flowers in a spike.

Cymes

Cymes are an inflorescence where the flower stops the growth of a stem and the next side bud continues growth at an angle. A branched cyme is also called a dichasium – a cyme in which two branches that are opposite and approximately equal arise and continue growth from either side of a stunted central flower.

Cyme.

Simple cyme.

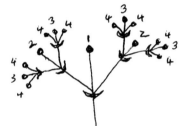

Branched cyme or dichasium.

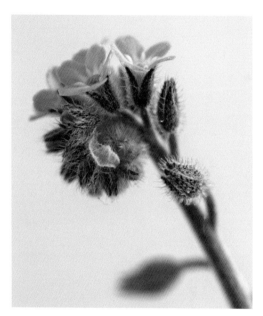

Myosotis, forget-me-not, simple or one-branched cyme.

Corymb

A corymb is an inflorescence where the flower stalk is longest at the bottom and becomes progressively shorter so that the flowers are held in a 'plate-like' mass rather than a spire.

Corymb

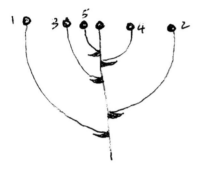

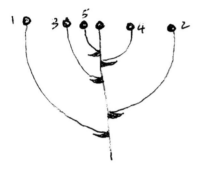

Corymb, *Iberis*, perennial candytuft.

Umbel

This is an inflorescence where flowers are massed on the same level but the flower stalks all arise from the same point at the tip of the flower stalk.

A Compound Umbel

This is an inflorescence where the umbel flower stalks each give rise to more stalks and other umbels of flowers.

Umbels

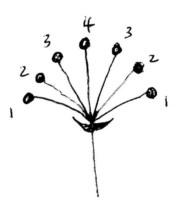

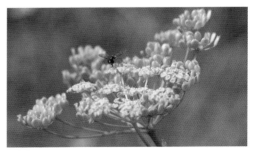

Compound umbels – garden parsnip *Pastinaca sativa* ssp. *hortensis*, with no bracts, few hairs, and oval fruits, flat with narrow wings.

Capitula

A capitulum – or head of flowers, called florets – grows on a flattened receptacle surrounded by an involucre of bracts. (These bracts are not sepals!) These florets (flowers) often have reduced whorls of parts. The sepals may be a tuft or pappus of hairs round the top of the inferior ovary (*see* pages 37–39). The outer ray florets may lack female or male parts, or both.

Note: The number of teeth at the end of the ray floret's strap-shaped corolla usually indicates the number of petals that are united.

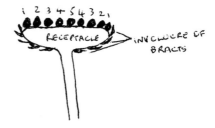

Head or capitulum.

Capitula (heads)

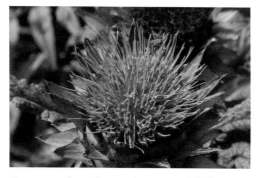

Cynara cardunculus, cardoon or artichoke thistle. All the disc florets are surrounded by large bracts.

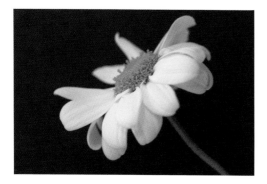

Argyranthemum, Marguerite daisy. The outer ray florets are white, and the inner disc florets are yellow. The bracts are not visible.

FRUITS

Botanically speaking the term 'fruit' refers to the ripe ovary wall of a flower's carpel with its enclosed seed(s), formed after fertilisation of the ovules by pollen.

Fruits may not look anything like one expects a 'fruit' to look like in a greengrocer's – for example rhubarb is not a fruit as it consists of leaf stalks; it isn't formed by a flower and contains no seeds! Many of a greengrocer's vegetables are 'botanical fruits' as they contain seeds – tomatoes, chillis, aubergines, peppers, cucumbers.

How fruits develop depends on a plant's particular strategy for dispersing its seed away from the parent plant, so that when the seeds start to grow or germinate, they may be in a better environment; and may not be in competition for resources (such as light, water and minerals) with the parent plant or any other of its 'sibling' seedlings as they grow.

Seeds may be dispersed by wind, water and animals, and the fruits of each plant type have evolved to develop modifications to ensure successful dispersal.

Fruits may appear to be a complicated subject with lots of different botanical types, but careful observation will help in your understanding of them, and help your paintings and illustrations.

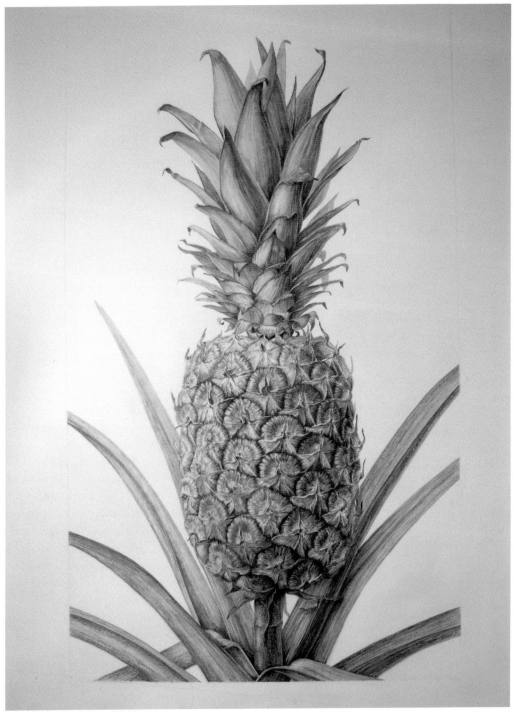

Penny Price, 'Pineapple'.

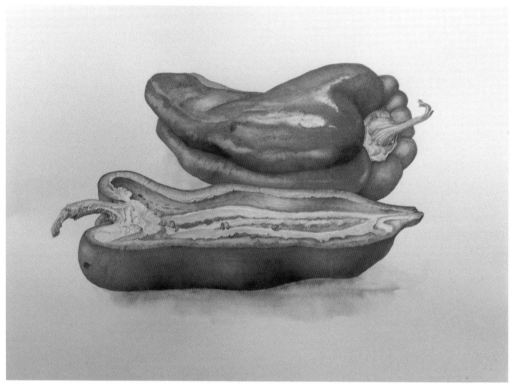

Penny Price, 'Red Peppers'.

Fruits can be classified as true fruits, false fruits or infructescences, where they develop from whole inflorescences (collections of flowers), and the individual fruits are not obvious, for example pineapple.

This section of this book is intended to be an introduction to various fruit types and how to recognise them, and what to look out for to inform your paintings; it is not a full botanical treatise. You do have to look at the carpels of the flower, the young developing fruits and the ripe fruits to distinguish some – for example almonds are not botanical nuts, as the ovary wall also forms a softer, fleshy outer layer that surrounds the tough-walled seed. This outer layer is shed when the seed is ripe, so the seed that you buy looks like a nut! Brazil nuts are actually seeds as they grow in a large heavy fruit that drops from very tall trees in the Amazon forest – the price of Brazil nuts represents the collectors' danger money, as many have been killed by the falling Brazil 'bombs'.

TRUE FRUITS

Achenes

Achenes are dry, one-seeded fruits, formed from separate carpels containing a single seed in each; the carpel wall hardens as it ripens. The remains of the stigma and style show that it is a fruit and not a seed.

Achenes

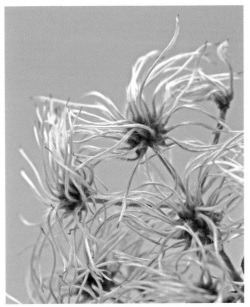

Clematis achenes with long hairy styles and stigmas to help wind dispersal.

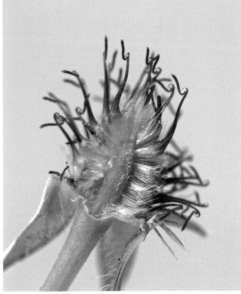

Wood avens with achenes (with hooked styles) for animal dispersal.

Buttercup achenes developing, with obvious yellow stigmas.

True Nuts

True nuts are achenes with a woody ovary wall (shell) surrounded by cupules of bracts. Some plants belonging to the Lamiaceae family – for example *Salvia*, deadnettle – have small woody nutlets in the bottom of the calyx/sepal tube.

Nuts and nutlets

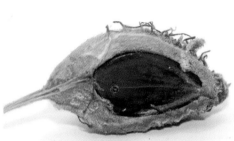

Beech nut surrounded by bracts growing from the peduncle (flower stalk).

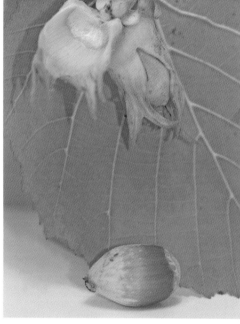

Filbert (hazel) nut surrounded by a cupule of bracts.

Four nutlets in the bottom of the sepal tube of white deadnettle (Lamiaceae).

Samaras

Samaras are one-seeded fruits that differ from other achenes in that the wall of the carpel is extended into a wing to enable wind dispersal.

Samaras, keys or helicopters

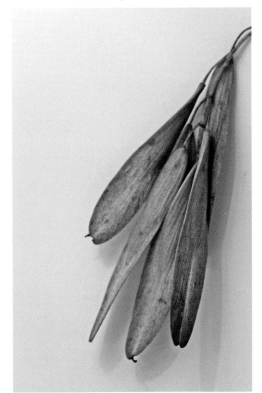

Ash keys or samaras with 'wings' that catch the wind for dispersal.

Maples and sycamores produce two joined samaras, often called helicopters.

Schizocarps

Schizocarps are 'splitting' fruits, where the ovaries split into dry, one-seeded parts called mericarps. They do not count as an achene as they still have part of the ovary wall surrounding them.

Schizocarps

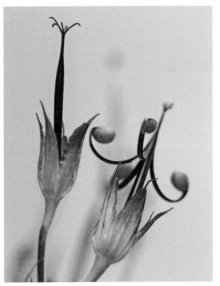

Cranesbill fruits, where the styles split from a central column when ripe and pull the ovary apart so the seeds are catapulted out for dispersal.

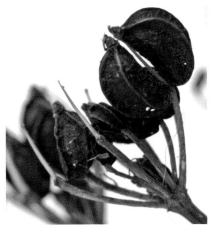

Alexanders showing the complete fruit with two styles (top); and the fruit splitting into two mericarps (bottom).

Pods or Legumes

Pods or legumes are formed from one carpel that splits along both margins (the top and the bottom) when it is ripe. The two halves or valves then twist apart to shoot the seeds out and away from the parent. This is an explosive seed dispersal mechanism.

Legumes or pods

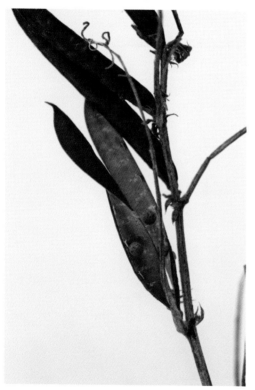

Vetch pods. The upper pods have not split open (dehisced) yet; the lower pod has split, showing twist-on valves and the remaining unshed seeds attached to the upper margins of the valves.

Follicles

Follicles are compound fruits formed from more than one carpel, which splits along the length of only one margin to expose the seeds (as compared with legumes).

Follicles

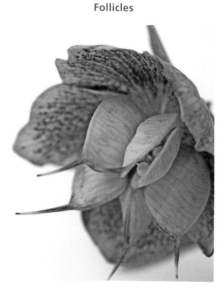

Hellebore follicles, one split along the outer edge to expose the seeds.

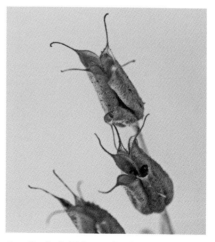

Aquilegia follicles split along the inner edge to disperse the seeds.

Magnolia fruits are aggregates of follicles, as compared with peony follicles that are individual.

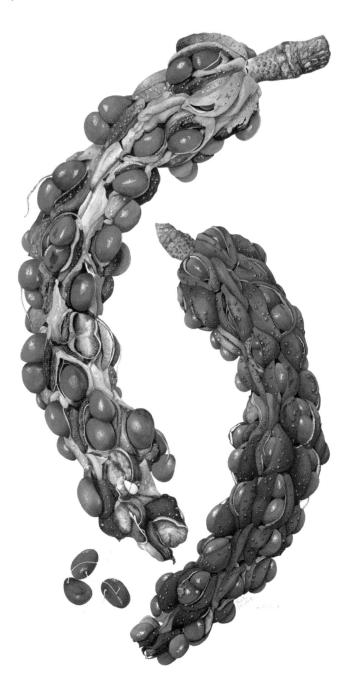

Beth Phillip, '*Magnolia sprengeri* "Westonbirt" Follicle Fruits'.

Siliculas

Siliculas (short and wide) or siliquas (long and narrow) are a specialised form of capsule formed by two carpels that are separated by a membranous false septum, to which the seeds are attached on both sides. When ripe the carpel walls separate to expose the shiny, silvery membrane or the septum and its seeds.

Capsules

Capsules are usually formed from ovaries made up of more than two carpels. Their shape is very varied but they are all dehiscent (open) to release their seeds. Poppies use a censer mechanism – like shaking a sugar shaker. Otherwise, wind shakes the fruit stalk and the seeds scatter or blow away.

Siliculas and siliquas

Honesty siliculas splitting from the base upwards to show the central septum and seeds.

Capsules

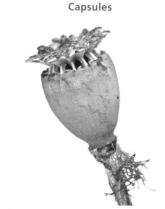

Poppy showing capsule valves opening under compound stigma.

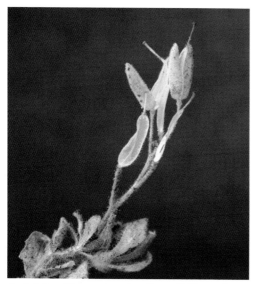

Aubrietia siliquas showing the splitting valves and the central septae or membranes.

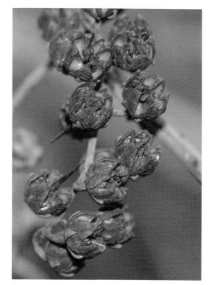

Woody capsules of *Pieris* – each splits into five sections to release the seeds.

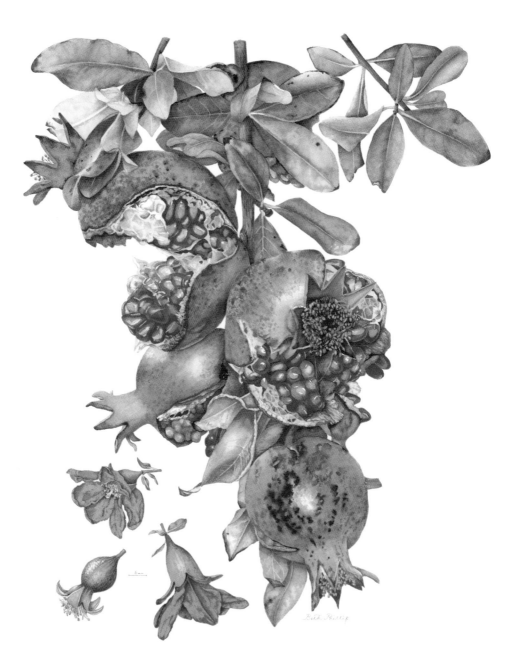

Beth Phillip, 'Pomegranates, *Punica granatum*'.

Berries

Berries are the simplest type of succulent; they are often many seeded fruits where the ovary wall (the pericarp) of three layers (epicarp, mesocarp and endocarp) becomes fleshy so as to attract animals to eat the fruit, thus enabling the dispersal of the seeds. Botanically berries are different to the general understanding of what a berry is.

Berries include cucumbers, tomatoes, aubergines, pomegranates and bananas, but not raspberries and strawberries.

Types of berry

Pomelo is a berry.

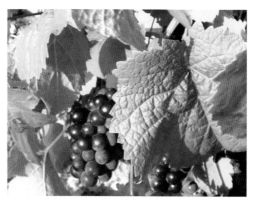

Grapes are berries.

The honeysuckle fruit is a berry.

Arbutus unedo (strawberry tree) berries. They are edible but have a different structure to the 'common' strawberry, whose plant is not woody.

In berries the outer layer (the epicarp) is a thick, non-oily rind; those with no internal dividing septae are known as 'pepos' – for example gourds, melons, pumpkin, passion-fruit.

Berries with a thick outer layer with a leathery skin with oils and internal septae are called hesperidia – for example citrus fruits, such as lemons, pomelo, oranges.

Berries called pepos

Berries called hesperidia

Pomelo, citrus fruit, growing in China.

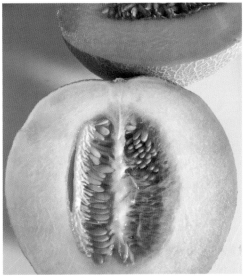

Gourds known as pepos.

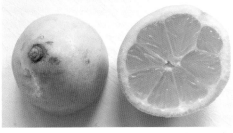

Lemon hesperidium showing its leathery, oily skin and septae (segments).

Melon, a typical pepo.

Drupes

Drupes are also fleshy fruits where the ovary wall (pericarp) is divided into three distinct layers; however, not all are fleshy. The endocarp (surrounding the seed) is woody and very tough, forming a 'stone'. Examples of drupes are plums, apricots, avocados, olives, coconuts (where the mesocarp is fibrous (coir) and the endocarp is hard – the part that we call a coconut!) walnuts and pecans, almonds.

Drupes

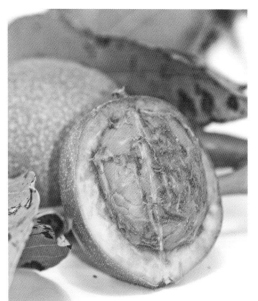

Walnut showing the fleshy mesocarp and the stony endocarp (the 'nut' shell).

Half almond

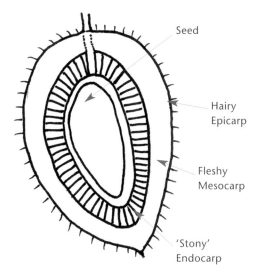

Seed

Hairy Epicarp

Fleshy Mesocarp

'Stony' Endocarp

Drupe structure.

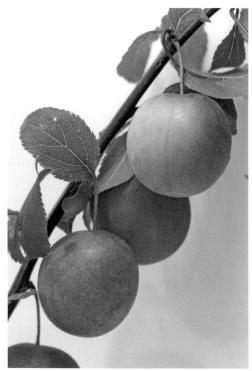

Plums, fleshy drupes with a hard endocarp or 'stone' surrounding the seed.

Aggregate drupes

Aggregate drupe fruits are made up of small individual drupes with woody pips surrounding the seeds – for example blackberries, raspberries, loganberries.

You can tell the drupelets are individual fruits as they each have the remains of the style and stigma at their free end.

Aggregate drupes or collections of drupelets

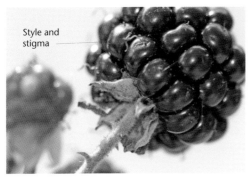

Blackberry aggregate fruit showing a ring of persistent sepals and dead stamens.

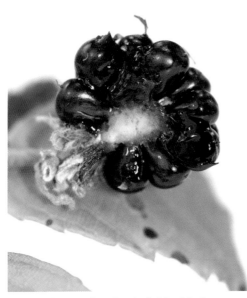

Half blackberry showing individual fruits (drupelets) attached to the receptacle and the remains of the flower.

Caryopsis

A caryopsis fruit is found in the Graminae or grass family, and is where a single-seeded fruit is completely fused to the pericarp (the outer layer of the ovary wall) – such as a sweetcorn kernel, a grain of wheat, an oat.

Caryopsis or grain – wheat grains

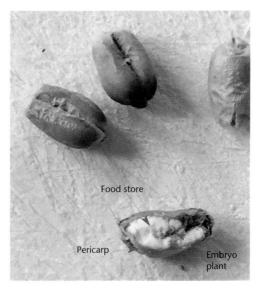

Bottom right: a grain cut in half longitudinally to show the food store (flour) just inside the tough pericarp. The embryo plant is long and thin and is in the space to the right in the centre of the grain (the approximate pink line).

False Fruits

These are fruits that have evolved their seed dispersal strategies by developing a part other than the ovary wall – such as the receptacle (flower stalk top).

Pomes

In pomes the receptacle becomes fleshy and surrounds the tough ovary wall (the 'core') containing the seeds – such as in apples and pears. The fruits develop from flowers with superior ovaries and an extended receptacle or hypanthium around the carpels/ovaries.

Pomes

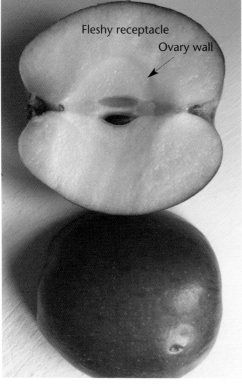

Fleshy receptacle
Ovary wall

Apple cut longitudinally. The true fruit is the core with seeds.

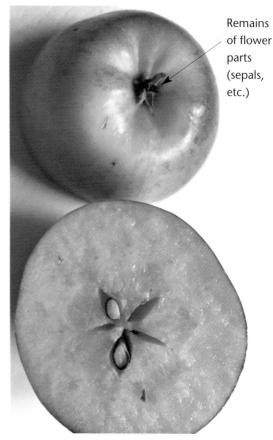

Remains of flower parts (sepals, etc.)

Apple cut transversely. The core showing five carpel divisions.

Hips and Haws

In hips and haws the receptacle swells and surrounds the true fruits or achenes (the ovaries containing the seeds).

Hips

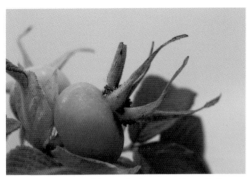

Developing rose hip with the remains of the flower parts at the free end.

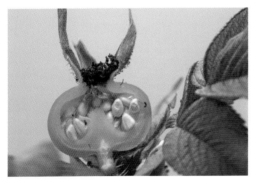

Half fruit with fleshy orange receptacle and dry one-seeded achenes attached to the tip of the receptacle.

Aggregate Fruits

In aggregate fruits the receptacle swells where the true fruits arise so the achenes are 'stuck' to the outside of the false fruit – as in strawberry.

Aggregate false fruits

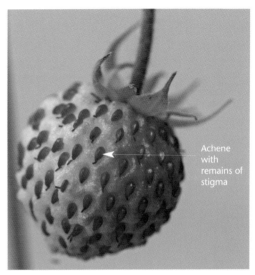

Achene with remains of stigma

Alpine strawberry with true fruit carpels/achenes on the swollen receptacle.

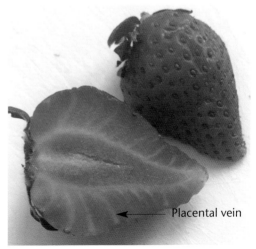

Placental vein

Half strawberry showing placental veins in the receptacle leading to each achene (fruit).

INFRUCTESCENCES

Infructescences are a group of fruits that develop in an inflorescence (group of flowers); they become fleshy and succulent once the flowers are pollinated and the seeds develop – for example mulberry, fig, pineapple, *Cornus kousa* dogwood fruit.

Infructescences

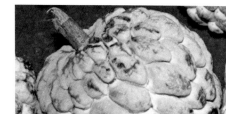

Annona, custard apple, where each 'scale' is a swollen fleshy flower containing a ripe fruit.

Cornus Kousa 'fruit' showing the remains of the stigma protruding from the centre of each swollen, fleshy flower.

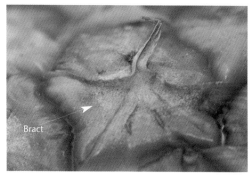

A pineapple flower, the bottom half covered by a bract.

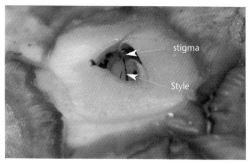

Bract and the top of the flower cut away to show the style and stigma and the remains of other flower parts. The whole flower is fleshy.

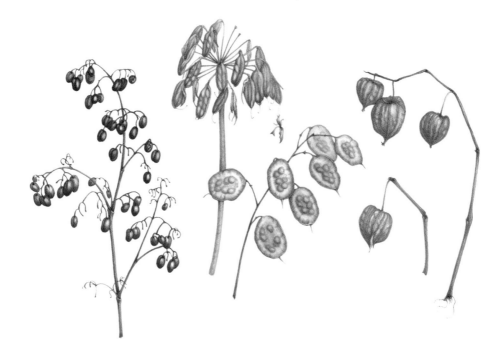

Carol Hartley, 'Late Summer Seed Heads'.

SUMMARY OF DISPERSAL MECHANISMS

In summary, fruits have developed in various ways to ensure that the plant's seeds are dispersed away from the parent plant and hopefully to a more auspicious growing site. Dispersal mechanisms have evolved in different plants to make use of different means of dispersal, using water, wind, or animals of various species.

Water dispersal uses water, and so the fruit must have a means of floating, whether it is the air trapped in the coir coconut fibres or hairs trapping an air bubble, or the fruit's shape being streamlined so it moves easily in water currents.

Wind dispersal mechanisms rely on the fruits having thin extensions that form wings or larger surfaces to catch the wind so they can be blown away. Alternatively, fruits may have hairy extensions to help them to float away on the wind. Some fruits produce very tiny seeds that are light enough to blow away when the fruit opens.

Mechanical dispersal methods rely on the fruit shaking the seeds out – for example the censer mechanism – or exploding them away when for instance ripe pods or capsules open and twist, or splitting the fruits so that the wind can catch them, such as various schizocarps.

Animal dispersal methods fall into three main categories:

* The fruits produce hooks, barbs or sharp-pointed awns (grasses) that catch in the fur or hair of passing animals, or on your clothing, so

that the fruit is taken away and picked off and discarded elsewhere.

* Juicy, succulent fruits are destined to be eaten by an animal that either swallows the seeds or discards them. When the seeds are swallowed – for example an apple pip – the seeds pass through the animal's digestive system and re-emerge in a convenient pile of natural fertiliser to grow really well – win-win for the plant strategy!

* In the case of nuts and grains, the fruits are collected by mice or squirrels and stored else-where.

As you may have gathered, plants often use a combination of dispersal mechanisms.

ILLUSTRATE DEVELOPING AND FULLY RIPE FRUITS

It is often a good idea to illustrate developing and fully ripe fruits so these mechanisms are clear in your pictures and explain the way a plant scatters its seeds.

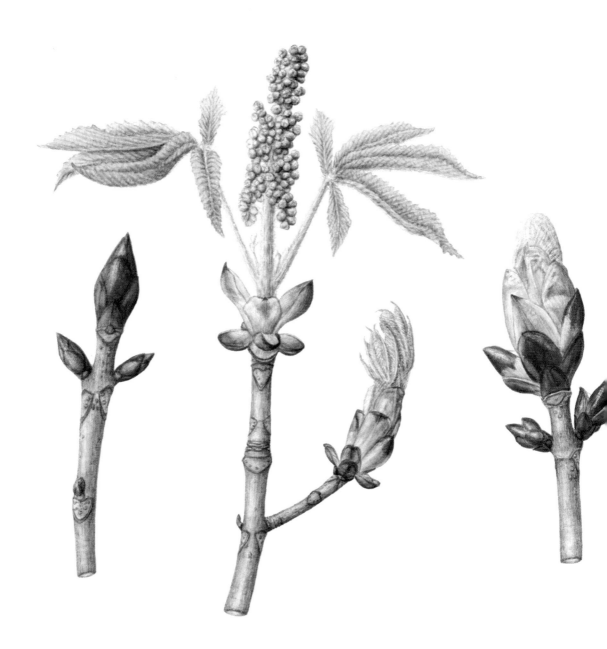

STEMS, STIPULES, WINTER TWIGS AND LEAVES

STEMS

Stems arise from the germinating seed's embryo shoot (the plumule), and are the part of the plant that connects the root system to all the aerial parts (above the ground) of a plant. In the veins, the woody xylem tubes take water and minerals up the plant, and the soft phloem tubes take the food (sugars and so on) made by the green leaves up and down the plant, and are continuous from the roots to all the other parts of the plant – the stems, leaves, flowers and fruits.

Stems may be different shapes, and the easiest way to show this is by including a transverse section through the stem at its cut edge. Shape is diagnostic in some families – for example the Lamiaceae (dead nettles) have distinct square stems with a hollow centre.

Stems also bear the growing points of a plant at their nodes (joints), in the narrow angle between a leaf stalk and the stem – the axillary buds (*axilla* is Latin for armpit) – and at the top, free end of the stem in an apical bud (at the apex). The apical bud has an inhibiting effect on the axillary buds, which don't grow unless the apical bud is removed.

Stems of Lamiaceae

White dead nettle with thickened tissue in the corners to make the stem more rigid. The stem is hollow.

Yellow archangel with a similar square stem, and hollow in the centre.

Left: Linda Pitkin, Horse Chestnut, *Aesculus hippocastanum*, 'Sticky Buds'.

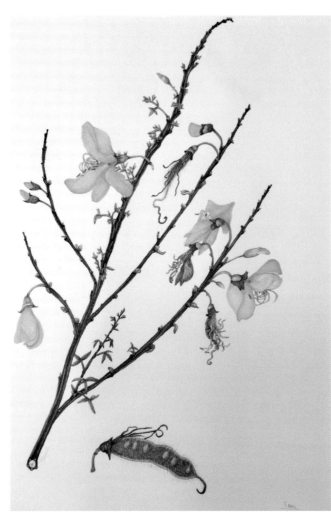

Detail of the leaf trace showing the raised leaf-trace patterns, from the lower node to the next node (joint) up the stem.

Watercolour painting of broom showing the stem shape with a transverse cut across the stem, leaf traces, flowers, fruit, buds, leaves, axillary buds and stipules.

PAINTING STEMS

On many stems, the stem veins (leaf traces) to the leaves are raised and form a particular pattern that needs careful observation.

PRUNING THE AXILLARY BUDS

Pruning or pinching out the tips of stems of plants causes the axillary buds to start growing, making the plant more 'bushy'. Gardeners use this to great effect to achieve shaping in topiary and hedge trimming and pruning.

Axillary buds

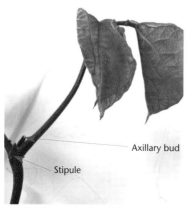

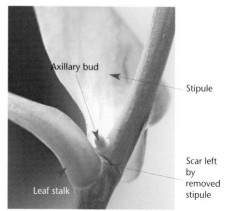

Small, rounded axillary bud of *Liriodendron*, the tulip tree.

Lab-lab bean leaf and junction with the main stem. Leaf stalked or petiolate.

Milkwort, *Polygala*, with small, green, hidden axillary buds.

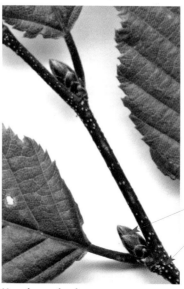

Hornbeam buds.

St John's Wort, *Hypericum*: sessile leaves (no stalks) with small, red axillary buds.

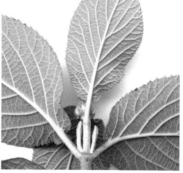

Viburnum with long, felted axillary buds.

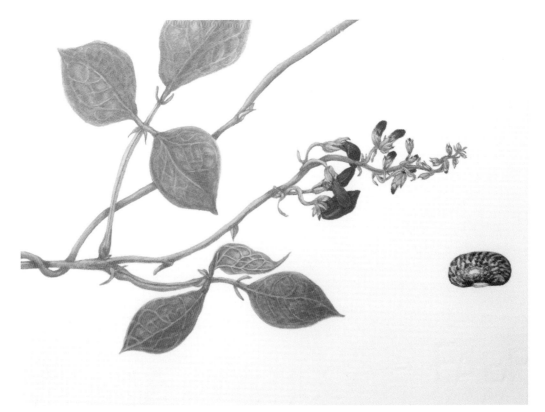

Painting detail of runner bean 'Painted Lady' showing the axillary bud where the leaf stalk meets the stem and stipules.

STIPULES

Stipules are outgrowths at the base of a leaf stalk (petiole), where it attaches to the stem at a node. They are often in pairs. They may be leafy and photosynthetic; spiny to protect the plant, such as in *Robinia*, the false acacia tree; modified to form tendrils to help a plant to climb, such as in *Smilax*; or only present in young shoots, and drop off as the plant matures, such as in hornbeam twigs.

Each plant with stipules has differently but diagnostically shaped stipules. Get them incorrect and your mistake will be obvious.

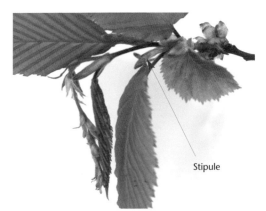

Stipule

Young growth of hornbeam showing pink stipules that fall off as the twig matures. It will leave a small, scarcely discernible scar on the twig.

Stipules

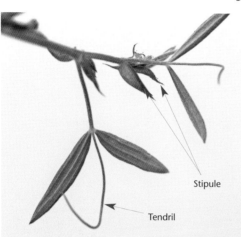

Bauhinia stipules, spiny for defence.

Meadow vetchling with paired, pointed green stipules, and one of the three leaflets modified to form a climbing tendril.

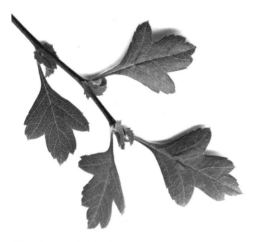

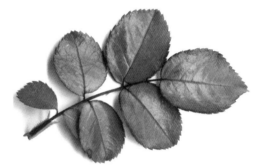

Rose leaf showing stipules attached to the base of the petiole (leaf stalk).

Hawthorn with leafy stipules at the nodes (stem joints).

WINTER TWIGS

Deciduous plants shed their leaves in winter to preserve water (when the ground water is frozen), and form buds with tougher bud scales, which protect the new growing points of the bud. The number of bud scales, their colour and pattern are all distinctive for each species of plant. These buds have a distinctive leaf scar below them, and the shape of these, and the arrangements of the veins, are also distinct, so need careful observation. Where last year's apical bud has grown out, the bud scales have dropped off and form a ring of scars, known as girdle scars. You can tell a year's growth as it is demarcated by these girdle scars.

The bark of woody twigs may have distinct breathing pores or lenticels: these are groups of loosely packed cells that allow gases into and out of the twig.

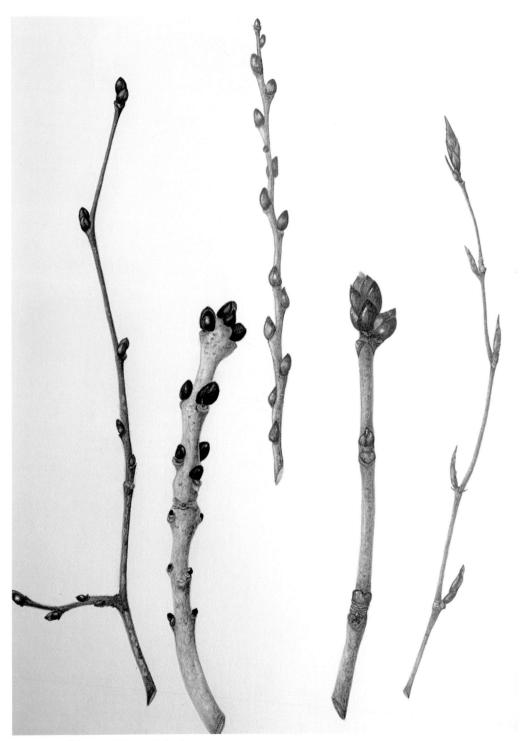

Victoria Wilkinson, 'Winter Twigs'.

Winter twigs

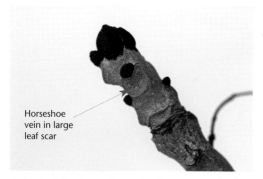

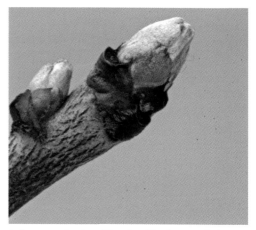

Ash black buds and large leaf scars, and bark with pale round lenticels.

Laburnum buds with raised leaf scars, hairy bud scales and long lenticels on the bark.

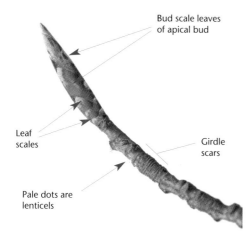

Parts of a twig. Beech twig with features labelled. Girdle scar to the apical bud is one year's growth.

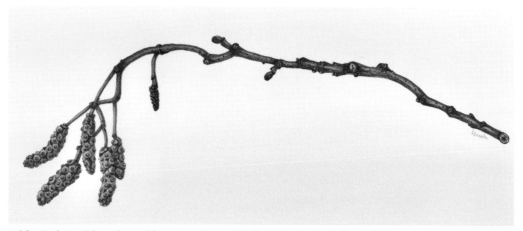

'Alder Twig', with male and female catkins, in ink with watercolour washes.

LEAVES

Painting leaves accurately is also important as their number, arrangement, shape and distribution on the stem are diagnostic for each plant and aid its identification. These features also indicate leaf adaptations that ensure survival in the plant's particular natural habitat – for example, hairy leaves are often found where water loss needs to be reduced on mountain tops, in extreme cold, or where it is windy and cold, or in deserts where it is hot and also desiccating. Leaf fall also occurs in droughts and other adverse conditions. Therefore the leaf structure often gives an idea of the plant's natural habitat.

Different species of a plant cannot always be recognised by their leaves (in the way that you can identify plants by their flower structure) as they have often developed environmental adaptations; however, these are often a disadvantage in times of climate change.

The main functions of leaves are as follows:

* They are the main organs of photosynthesis (food production) from water, light energy and carbon dioxide gas.
* They are the plant's main organs of gas exchange (like our lungs) as they have pores called stomata that allow the diffusion of gases (and water) in and out of the leaf.
* They are the main organs of water loss (by transpiration), as they pull the water columns up the plant from the roots in a continuous stream. If water loss is excessive, plants wilt and the stomata close in order to conserve water. Thus leaves maintain the plant's water balance in the same way as your kidneys do.
* Leaves may also be modified to store food or water; to help plants to climb; or to protect themselves from pests and extreme weather conditions.

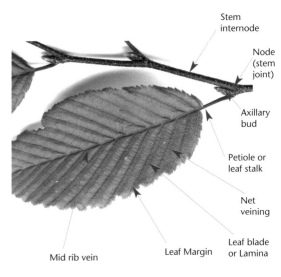

Stem internode

Node (stem joint)

Axillary bud

Petiole or leaf stalk

Net veining

Leaf blade or Lamina

Leaf Margin

Mid rib vein

Detail of hornbeam stem and leaf – a typical dicotyledonous leaf.

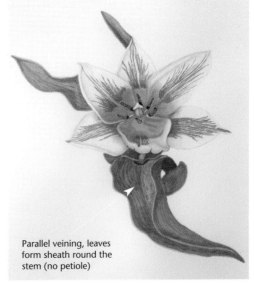

Parallel veining, leaves form sheath round the stem (no petiole)

Dwarf tulip. Watercolour painting showing parallel veining in monocotyledonous leaves.

Looking at Leaves

The following pictures are examples of dicotyle-donous leaf types with net-veined leaves, and a fern.

Leaf types

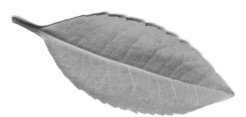

Arbutus unedo, petiolate (with leaf stalk), entire blade and toothed margin.

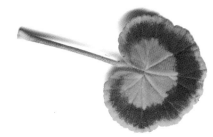

Leaf blade – simple, entire and palmate in shape: all the main veins fan out from the top of the leaf stalk.

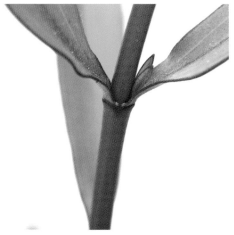

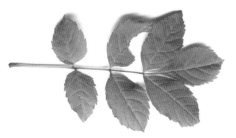

Fraxinus, ash-leaf blade divided into pinnate leaflets round the mid-rib and side veins, so a compound leaf.

Hebe, sessile (no leaf stalk) – the leaf blade joins directly on to the stem.

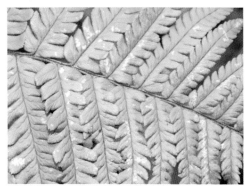

Buddleja, leaf blade or lamina, simple and entire (whole). Pinnate shape, with mid-rib and side veins like fish bones.

Fern, *Dryopteris feilix-mas*, bipinnate leaflets – the frond's pinnate leaflets are divided into smaller pinnate leaflets. It is not a flowering plant!

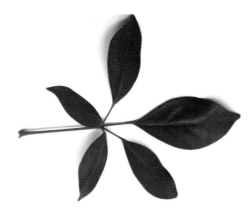

Schefflera actinophylla, compound palmate where the leaf blade is divided into pinnate leaflets round the main veins arising from the top of the leaf stalk. The leaflets are entire and smooth edged.

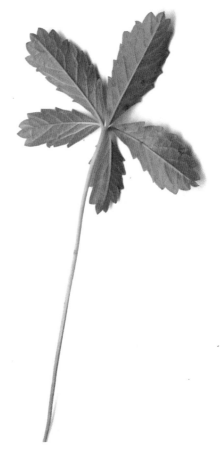

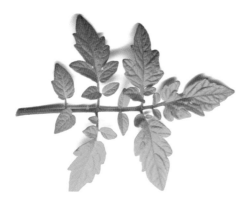

Tomato – the compound leaf has divided into pinnate leaflets round the side veins. There are lobed leaflets of various sizes.

Cinquefoil, compound palmate. The leaflets have toothed edges. All leaflets arise from the top of the petiole (leaf stalk). This shows the underside of the leaf with obvious venation.

The following pictures are examples of mono-cotyledonous leaf shapes with parallel-veined leaves.

Leaves – monocotyledons

Bamboo grass leaves with blades attached to sheaths that surround the stem.

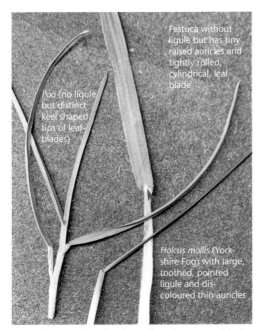

Festuca without ligule but has tiny raised auricles and tightly rolled, cylindrical, leaf blade

Poa (no ligule but distinct keel shaped tips of leaf-blades)

Holcus mollis (York-shire Fog) with large, toothed, pointed ligule and dis-coloured thin auricles

Grass leaves showing junctions between blade and sheath.

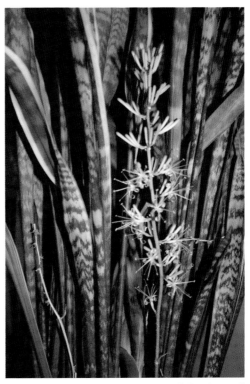

Mother-in-law's tongue with parallel veins and variegated cross-banding with yellow edges. The bases of the leaves are sheathing.

Orchid, in this case with food storage pseudobulb swellings at the base of some leaves. The bases of the leaf blades are sheathing.

The following pictures are examples of common leaf shapes.

Common leaf types

Pittosporum, sinuous or wavy edges.

Mallow, palmate leaf with lobes and regular teeth on the margins of the leaf blade.

Undulate, where edges are so wavy that they point upwards and downwards from the main axis. In this case the wave edges are pointed and end in a protective spine – for example, holly.

Platycerium bifurcatum, antler fern fronds with dissected or divided leaves.

Watermelon *Peperomia*, peltate leaves with the leaf stalk attached to the underside of the leaf blade (like an umbrella). Note the veins radiating out from the attachment of the stalk and blade.

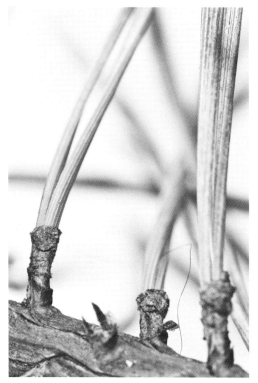

More peltate leaves. This Chinese succulent is closely related to the stinging nettle! Plants cannot be identified by just their leaves – you need flowers.

Leaves reduced to needles prevent excess water loss. Needles arise from sheaths – for example pine trees – and the number of needles in each bundle is diagnostic.

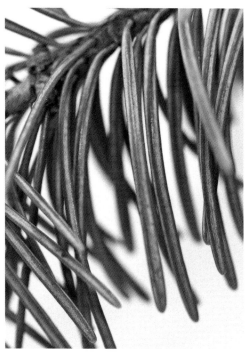

Single needles with rolled edges further reduce water loss – for example Douglas Fir.

Leaves may vary according to the age of a plant or in seedlings.

Juvenile and Adult Leaves

In some plants the juvenile leaves are very different to the adult leaves, as the eucalyptus, and this can be confusing, while some plants have only slightly different juvenile and mature leaves, as the ash. However, both are diagnostic and should be included in your painting.

Seed leaves or cotyledons

For example, sycamore seedlings with epigeal germination (where seed leaves or cotyledons are strap shaped and come above ground) and are followed by the first true leaves.

NOTE ABOUT COTYLEDONS

In hypogeal germination the cotyledons stay beneath the ground and only the true leaves emerge – for example, in the broad bean.

Leaf Veins and Venation

The positions of the veins in your leaves may not seem terribly important, but this can be the detail that destroys the credibility of your botanical painting. You need to see where the larger veins run from, and where they end up. Do they

Mature and juvenile leaf shapes

Eucalyptus: adult on the left and juvenile on the right. Note that the adult leaves are identical on both sides as they hang down. In some plants the juvenile and mature leaves are only slightly different.

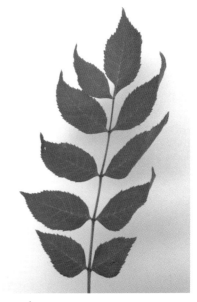

Mature ash.

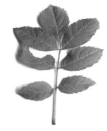

Immature ash.

empty into a marginal collecting vein or do they lead to specific parts of the leaf – for example in the centre of a tooth on the margin? Are they proud of the leaf surface or are they sunken? Careful observation is needed.

It is often easiest to look first on the underside of the leaf, where the veins are usually more prominent, or to put your leaf on a lightbox.

I have already discussed pinnate and palmate venation; the pictures also highlight other vein configurations to look out for on the undersides (ventral surfaces) of the leaves.

Leaf venation

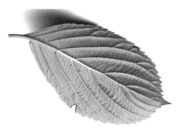

Pinnate venation with a vein leading to the tip of each tooth at the edge of the lamina (leaf blade): *Viburnum* lower surface.

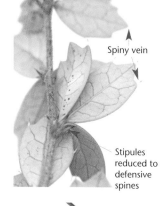

Spiny vein

Stipules reduced to defensive spines

Berberis leaves showing the pale ventral surface with obvious collecting veins and the main veins leading to the margins of each tooth, where the vein emerges as a defensive spine.

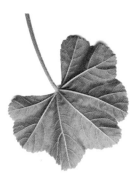

Palmate venation with main veins running to the edge of each lobe and the small teeth on the edges of the lamina: mallow lower surface.

Upper surface of the *Hosta* leaf showing parallel veins. The upper surface of the leaf is pillowed between the veins.

Mid-rib running to the tip of the drip tip at the apex of the leaf. Other main veins curve to form collecting veins before they reach the edge of the lamina. The network of veins is very prominent: *Cornus* (dogwood).

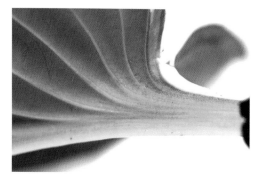

Leaf stalk underside showing packed parallel veins, then spreading out in the leaf blade in *Hosta*.

Leaf Surfaces

Some leaves, such as Eucalyptus adult leaves, are identical on their two surfaces, which generally indicates that they hang down off the branches. Both surfaces are therefore exposed to the same environmental conditions, and neither is damaged by very strong sunlight. The leaves are leathery and tough (to prevent damage and diseases) and move in the slightest of breezes to stay a little cooler so the leaf chemistry works!

Most other leaves have an obvious upper (dorsal) surface that is exposed to most light for photosynthesis (food making); it also has to resist bacterial and fungal infection, and must prevent excess water entering or damaging the leaf and its cells.

The lower (ventral) surfaces of leaves generally have most of the pores called stomata, which let gases in and out and also balance the amount of water vapour being lost from the leaf/plant so it doesn't wilt, dehydrate and die.

These lower surfaces may also have hairs to reduce water vapour loss, pits or deep troughs to hide the stomata to reduce water evaporation; or possibly the leaf edges may roll to keep water vapour from escaping. In extreme cases of drought or freezing ground water, the leaves are shed or reduced to spines – as they are in cacti.

All these features are important to note and illustrate, and indicate the plant's natural environment – its habitat.

I will not go into the different types of hairs you can find using a microscope – they range from simple (one cell), glandular (oil or chemical secreting), multicellular, stellate (star shaped) or like a hypodermic to inject (like those of stinging nettles). This is a fascinating study in itself.

Beware pseudo 'leaves', which in reality are flattened stems (*cladodes*) that take on the role of photosynthetic leaves, for example in

Leaf surfaces

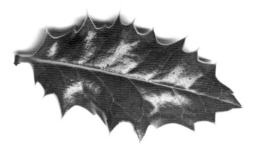

The upper surface of the holly leaf has a thick, protective, waxy, waterproof cuticle that is hard for fungi and other pathogens and water to penetrate. It is dark green to maximise photosynthesis.

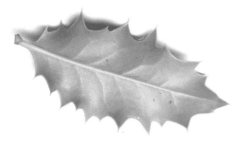

The lower surface of the holly leaf is lighter and without a thick cuticle, but with the majority of pore-like stomata. This is the main area of water loss and of gas exchange.

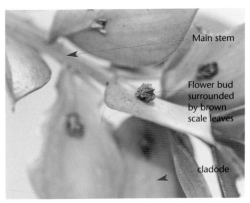

Main stem

Flower bud surrounded by brown scale leaves

cladode

Cladodes – butcher's broom with brown scale leaves and a developing flower bud, showing that the green 'leaf' is a cladode or stem.

butcher's broom. They often have tiny scale leaves and buds in their axils. These 'leaves' may also at times have a flower or a fruit attached. In other instances the leaf blade might be absent, and the leaf stalk has become flattened and photosynthetic but lacks typical leaf venation – for example as in the flattened 'leaves' of some acacias. These 'leaves' are called *phyllodes.*

Leaf adaptations

Lavender leaves showing stellate hairs on the surfaces and rolled edges on the lower surface to trap water vapour around the stomata to prevent water loss. The raised mid-rib causes the lower surfaces to form deep channels.

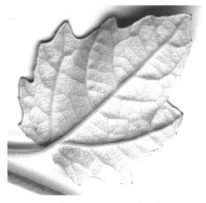

White poplar leaf, the underside covered in a thick layer of white hairs.

White poplar leaf, magnified, showing tomentose under the surface with a thick felt of hairs.

Lavender leaves showing the inrolled margins of the underside of the leaf.

Senecio articulatus with succulent stems and dying leaves being shed due to drought. The stems will grow new leaves and daisy-like flowers once water is more available, after rains break the drought. The leaves would lead to too much water loss and the death of the plant in times of drought.

Cactus showing how the stem is adapted for water storage and photosynthesis, and the leaves reduced to spines so there is no water loss from them. The distinctive hairy areoles protect the flower and other buds and distinguish cacti from succulents.

Leaf Arrangements or Phyllotaxy

There are several types of leaf arrangement up a stem to observe. They never vary within each species of plant. Getting the arrangement incorrect means discarding your picture and starting again. Don't be tempted to 'stick in' an occasional leaf because you think it looks better aesthetically!

These arrangements ensure that the leaves get as much light for photosynthesis as possible and do not shade each other. If leaves are shaded they cannot produce as much food, and the plant starts to become weak and may eventually die of starvation.

Alternate leaf arrangements are found where there is only one leaf at each node (stem joint). *Spiral arrangements* are alternate, but one has to pass through several turns of the stem and more leaf nodes to get back to the same vertical row position of the leaves.

Looking down on a stem gives you the 'leaf mosaic' for a plant, which ensures that maximum light reaches each leaf. The simplest phyllotaxy is 1/2 , then 2/5 (a Fibonacci series), where adding the top two numbers and the bottom two numbers in the sequence gives the next combination possible – 3/7 and so on.

Opposite distichous leaf arrangements occur

Leaf mosaics

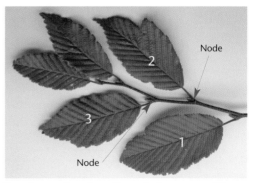

Hornbeam showing alternate leaves on either side of the stem (forming two vertical rows) with a flattened appearance. The arrangement is opposite distichous. Leaves 1 and 3 are in the same position after one turn round the stem and passing through two nodes – giving the simplest 1(turn)/2(node) phyllotaxy.

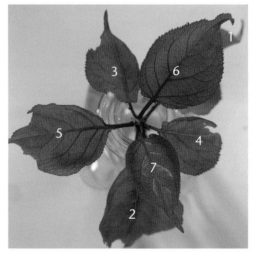

Apricot twig showing an alternate spiral arrangement. Leaves 1 and 6 are in the same vertical row, as are 2 and 7 – that is, the leaves are in exactly the same position on the stem – two turns round the stem and past five nodes (leaf attachments). The phyllotaxy is 2/5.

where two leaves are found opposite each other and are all in the same plane up the stem.

Opposite decussate arrangements are where the two leaves are opposite each other but are at right angles to the pair of leaves above them.

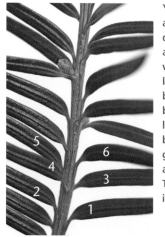

Yew has an alternate distichous arrangement, where the leaves look to be in two rows because the leaf stalks have been twisted to give this 'false' arrangement. The phyllotaxy is actually 2/5.

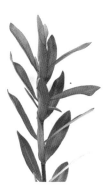

Hebe also has opposite decussate but sessile leaves (without leaf stalks).

The last leaf arrangement is whorled, where there are more than two leaves attached at the node.

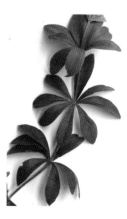

Leaves in whorls (rings) at each node. As here, in Woodruff.

Leaf arrangements

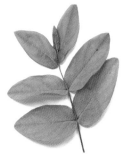

Hypericum has a sessile, opposite distichous arrangement, which gives the branch a flattened look.

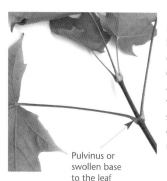

Norway maple has a petiolate, opposite, decussate arrangement where successive pairs of leaves are at right angles.

Pulvinus or swollen base to the leaf stalk

SUMMARY

All these details of leaves, stems and twigs need close and careful observation so they are correct. I generally take many close-up photos of these details, which seem boring but are so important as reminders if the plant has died or wilted before your painting is complete.

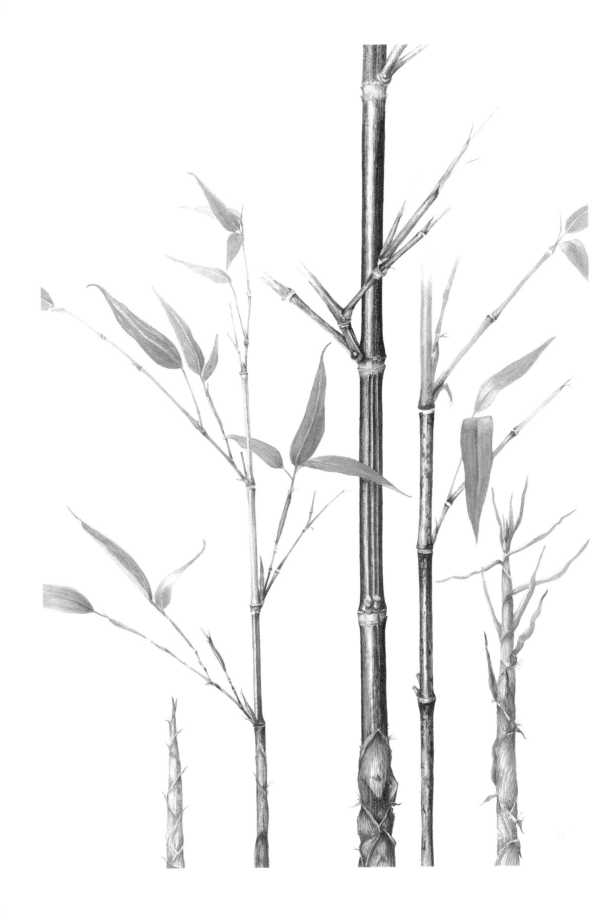

DISTINGUISHING GRASSES, RUSHES AND SEDGES

Grasses, rushes and sedges are counted as flowering plants, even though the wind-pollinated flowers are very much reduced and have their own terminology, rather than the four whorls of parts found in showier, animal-pollinated flowers.

GRASSES

The grasses in the family Graminae make up one of the largest plant families and are economically of huge importance, but are often the least illustrated as they are often so difficult to distinguish without a very close look!

The growing points (apical buds) of grasses are hidden at the base of the leaves on underground stems and so are not damaged by mowing, trampling or grazing. This makes them more resilient than plants with growing points at their tips, although plants with a tight, low rosette of leaves are also more resilient – for example buck's horn plantain – and are found on trampled footpaths.

Unlike plants with showy, easily distinguished flowers, grass plants can be identified by their stems and leaves, and a feature called a ligule at the junction of the leaf sheath and the leaf blade. All these features must be illustrated, and also the shape of a grass blade and its tip, in order for grass plants to be recognisable. Poa are grasses with keel-shaped tips.

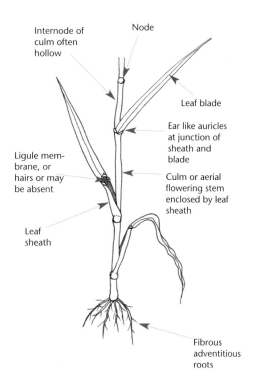

Internode of culm often hollow

Node

Leaf blade

Ear like auricles at junction of sheath and blade

Ligule membrane, or hairs or may be absent

Culm or aerial flowering stem enclosed by leaf sheath

Leaf sheath

Fibrous adventitious roots

Parts of the features of a typical grass plant.

Left: Penny Price, 'Black Bamboo, *Phyllostachys nigra*'.

Ligules and auricles

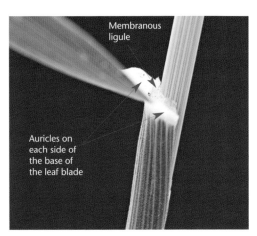

False oat-grass ligule and auricles.

Bamboo

Buddha belly bamboo with short internodes; Guillin, China.

Bamboo showing a leaf sheath and ligule.

The leaf blade may be flattened, folded along a central vein, in-rolled or almost solid. The tip of the leaf blade may be pointed, or blunt or keel (boat) shaped. These features also help to identify a grass.

At the junction of the leaf sheath and the blade there is usually a ligule of a thin membrane or hairs, or more rarely it may be absent. The shape and make-up of the ligule is species specific, identifies the grass, and must be shown on your picture.

Auricles may be present in some species: these are thicker, ear-like projections on either side of the point where the leaf blade meets the leaf sheath. They need illustrating. For instance, Buddha belly bamboo is a large grass with short internodes visible on the woody culms (canes). The leaves have sheaths, ligules and blades.

Grass flowers are usually held on long stalks above the leaves so that wind pollination is facilitated and less pollen is wasted as it will avoid being caught on the leaves.

The arrangements of grass florets (flowers) are diagnostic for different genera, and the inflorescences may be racemes, spikes or panicles, and

Grass flowers

Tussock grasses in China, showing the tall flowering stalks above the leaves.

Rice – spikes of flowers growing in China.

may differ in shape and size. The flowers are usually bisexual, but there are some grasses with distinct male and female flowers on the same plant, such as maize, and others with male and female flowers on separate plants, such as pampas grass.

Grass flowers are enclosed in units called spikelets. The flowers have no sepals or petals, and are surrounded by two modified, scale-like bracts called glumes, which may have long, thin, spiky awns – as, for example, in barley.

As the spikelet matures these glumes move apart and expose the reduced flower(s) on a thin stalk or rachilla. Each flower consists of two bracts: the lower one is called the lemma, and the upper one is the palea, and these enclose two lodicules on either side of the ovary, the stamens, with large, dangly anthers, and the carpel of the ovary, style and long feathery stigmas for catching passing pollen grains.

In good weather (so the pollen grains stay dry and light), the lodicules swell and force the palea and lemma apart; the stamen stalks grow really fast so the anthers dangle outside the flower to shed pollen into air currents; and the stigmas lengthen and also dangle outside the flower to catch pollen grains and allow pollination to happen so the ovary sets seed.

Look carefully at different ages of flowers, as differences in the glumes and lemmas between

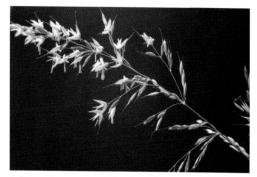

False oat grass panicle showing open bisexual flowers on the left, and closed spikelets on the right.

Briza media, quaking grass, showing spikelets on very thin stalks so they move in a breeze. The ligule is tall and membranous and tight to the stalk.

Grass flower detail

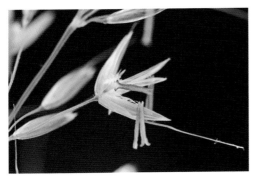

False oat grass open spikelet ready for pollination.

species also help grass identification – size, shape, thickness, hairs, veins, bristles and teeth. You may need a magnifying glass to make this easier.

The ripe ovaries remain surrounded by the palea and lemma, which form chaff when the ripe grain (a caryopsis fruit) is separated from them. The palea and lemma may also develop bristles or awns to help disperse the fruit by clinging on to animals (and your socks), and eventually helping the ripe grain bore into the ground.

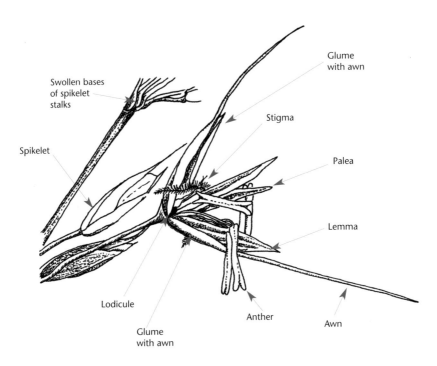

False oat grass diagram, showing a closed and an open spikelet with two flowers ready for pollination.

RUSHES AND WOOD RUSHES

Rushes (*Juncus*) and wood rushes (*Luzula*) belong to the Juncaceae family and are the commonest genera of the family. They generally occur in moist or shady habitats. They are perennials and form clumps that often grow from underground stems called rhizomes. The leaves grow in two or three rows up the stem (this feature may be unclear), and the leaf bases

Wood rush

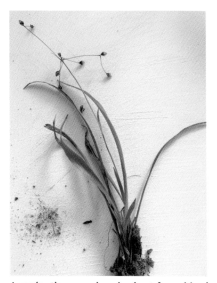

Rushes

Juncus acutiflorus, showing two rows of leaves sheathing the middle stem. Also shown is the underground stem or rhizome. The leaf blades are round and pointed.

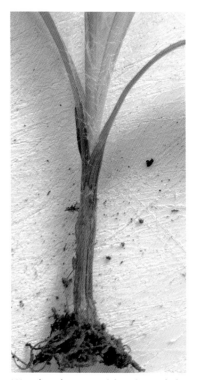

Luzula, the wood rush plant found in damp woodland. It has broad leaf blades with very long hairs.

Juncus effusus: the cylindrical leaf bases are sheathed, and the leaves taper to a point at the free end.

Wood rush stem with coloured sheaths, and the leaves showing the characteristic long hairs.

may sheath the stem.

The leaf blades in rushes have pointed tips and may be flat, rolled, channelled, round or cylindrical, or smooth (hairless), and may contain pith.

Wood rushes have flat leaf blades with long white hairs along their margins.

The flowers of rushes and wood rushes are much reduced, but the parts are in distinct whorls. The inflorescences are either cymes, or corymbs or heads, and are on the top or the side of the stems.

The sepals and petals are thin and papery and identical, and are called tepals (or the perianth) – there are two whorls of three of each. There are also two whorls of basifixed, stiff stamens (three plus three). The three carpels are fused in a superior ovary with three long stigmas on top to catch pollen. The ripe fruit is a dry capsule with three loculi (holes): this contains the seeds.

The features of the flowers and the leaf sheaths and leaf blades of rushes are most important, as it is these that distinguish members of this family from grasses.

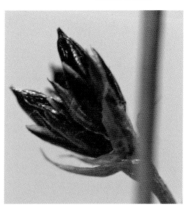

Rush fruits

Juncus acutiflorus: fruit capsules and the remains of the tepals (perianth) and bracteoles.

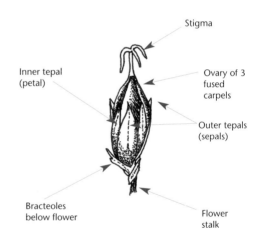

Juncus: diagram of the developing non-fleshy fruit capsule and the remains of the flower. The stamens are missing.

Labels: Stigma; Inner tepal (petal); Ovary of 3 fused carpels; Outer tepals (sepals); Bracteoles below flower; Flower stalk

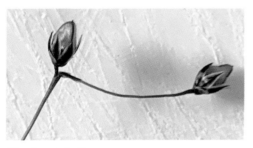

Wood rush fruits.

SEDGES

Sedges belong to the Cyperaceae family and are also found in damp or semi-aquatic wetland habitats. There are ninety genera, but the most common are *Carex* (true sedges), *Cyperus* (papyrus) and *Cladium* (saw sedges). Do not be fooled by their common names, as these may easily lead you astray. For example cotton grass is not a grass; also spike rush, bog rush and club rushes are not rushes but sedges! However, they all share the family characteristics.

These plants also have underground stems called rhizomes and form tussocks or mats. Sedges are the most grass-like (compared with rushes) as they are herbaceous (not woody), with flattened grass-like leaf blades. However, they have triangular-shaped stems in cross-section, which the leaves spiral round in three rows. Looking down on the plant, the leaves form a distinctive triangular pattern. The leaf bases tightly sheath the stem, and the ligules are fused to the leaf blade for most of their length.

The stems have inconspicuous joints (unlike grasses) and are pith filled.

The flowers are also very reduced, and form spikelets with a central stalk (the rachilla) with spiral or distichous (paired) arrangements of sessile bracts (or glumes or scales) that subtend a single unisex or bisexual flower. These spikelets may be grouped into cyme, panicle or raceme type branched inflorescences that may contain one to many flowers.

Each flower is in the axil of a scale, glume or bract. The sepals and petals (the perianth) are either absent, or reduced to scales or hairs. They each have three stamens with basifixed anthers. The female parts (the gynoecium) consist of a two- or three-carpelled, superior ovary surrounded by an inflated bract (perigynium) from which two to three styles protrude to catch pollen grains.

Sedge fruits are two- to three-sided achenes or nutlets (as compared with the capsules of rushes and grass caryopses or grains).

Sedge plants

Carex, sedge plant showing flower spikelets. The male flowers have long, dangly, yellow anthers. The female flowers have feathery white stigmas hanging outside the flowers.

Showing the leaves in three rows.

Showing the triangular stem with the leaves wrapped round the three angles.

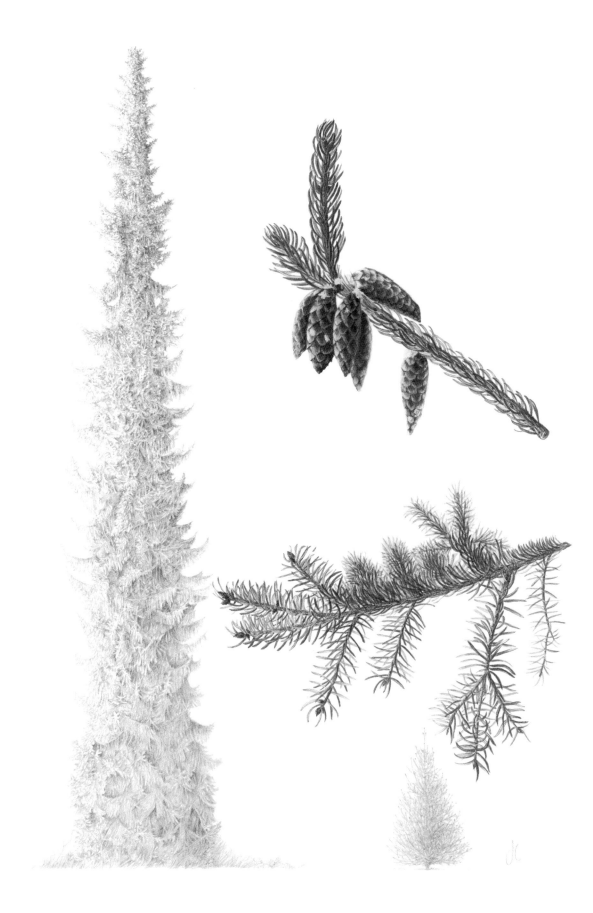

CONE-BEARING TREES AND SHRUBS (THE GYMNOSPERMS)

The gymnosperms is a group of six families that includes all the rest of the higher plants with well developed root, stem and leaf systems; these systems are connected by a well developed water and food transporting system of conducting tubes (the vascular tissues).

They differ from the flowering plants in that the conducting tissue does not include tough, waterproof, woody xylem tubes, so the wood is classed as 'softwood'. Resin canals are common, and the wood is resinous. The bark is often scaly.

Their leaves are often reduced to needles to reduce water loss, as they often occupy habitats that are very cold, windy or dry, and where water is in short supply. They all lack flowers, but have 'cones' that surround their sex organs which, once pollinated, give rise to 'naked' seeds that are not enclosed in an ovary wall or fruit. Hence the group name, as *gymnos* means naked and *sperm* means seed.

Cones are this group's reproductive equivalent of flowers, as they bear the male and female reproductive organs. Male and female cones are unisex, but both male and female cones usually occur on the same plant.

Cones are made up of spirally arranged, reduced, scale-like leaves that surround and protect the sex organs. Female cones catch

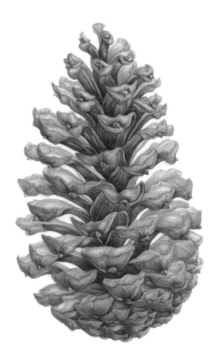

'Pine Cone', Carol Hartley.

passing pollen grains and subsequently protect developing seeds until they are ripe, and then aid dispersal of the seeds in some way. In juniper, the female cone scales become fleshy

Left: Jackie Copeman, 'Serbian Spruce, *Picea omorica*'.

and the cone looks like a berry, but isn't! Yew seeds develop a red fleshy aril that is also not to be confused with a berry.

ARILS

An aril is a fleshy outgrowth that grows from an ovule's stalk. For example, arils are found on nutmeg seeds (the mace), as the red part surrounding a pomegranate seed, as the slimy coating on passionfruit seeds, as the white flesh surrounding a lychee, and in the cashew apple attached to the cashew nut.

'Conifers' belong to a large group of plants from four of the plant families of the Gymnosperm families. These four families include pines, yews and podocarps, the cupressus and araucaria (monkey puzzle), Wollemi pine, Norfolk Island pine and so on. The main distinguishing features of each of these plant families are described below, so you know what is important to illustrate.

THE PINE FAMILY

The pine family, the Pinaceae, includes the pines (*Pinus*), spruces (*Picea*), larches (*Larix*), Douglas firs (*Pseudotsuga*), firs (*Abies*), cedars (*Cedrus*), hemlock trees (*Tsuga*), and so on. These are evergreen, resinous woody plants with branches in radially symmetrical rings. Lateral (side) branches may be long shoots, or reduced to short spur shoots, or may be even smaller, as dwarf shoots. The leaves are needle-like, and may occur singly or in bundles called fascicles containing two to five leaves.

Pine (*Pinus*) twig with lateral branches reduced to short shoots with bundles (fascicles) of needle-like leaves surrounded at their base by a membranous structure. Brown scale leaves are on the twig at the base of each bundle. The number and length of needles in a bundle help determine the species.

Douglas Fir (*Pseudotsuga*) twig with flattened leaves with rolled edges, and tiny leaf stalks with rounded bases. The leaf scars (when the leaves fall off) are round and not on projections. The buds are distinctive, being sharply pointed and with papery, brown bud scales.

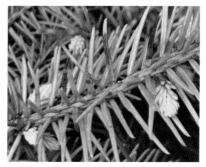

Spruces or Christmas trees (*Picea*) have needle-like, four-angled or flat leaves without leaf stalks that are attached to small cushion-like projections called 'pulvini'. These projections are separated by leaf trace grooves, and remain after the leaves fall.

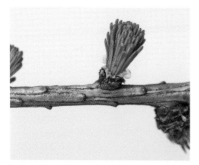

Larch (*Larix*) are deciduous and lose their spirally arranged flat leaves, leaving raised leaf scars and obvious leaf traces. Short, round lateral shoots produce distinct clusters of leaves at their tips.

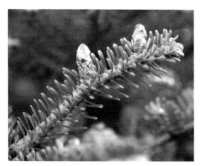

The firs (*Abies*) have flat, rigid leaves and flattened, rounded bases that leave a concave (indented) scar when the leaves fall. The buds are oval and blunt.

Hemlock trees (*Tsuga*) have slender branches with short, blunt, leaves of flattened, slightly angular needles on forward-angled projections. The needles appear in two rows on the upper side of the shoots. These needles are distinctive as they are all of variable lengths and have twisted leaf bases to bring them parallel with the stem. The tips of the branches droop.

Metasequoia, Dawn Redwood, has persistent reddish brown, shallowly ridged branches that carry the deciduous branchlets with leaves in more or less two rows. The leaves are horizontal and ribbed, and taper abruptly to their long decurrent (run-down twig) bases. The upper surface of the leaves is bright green, and the under surface is light green with a raised mid-rib.

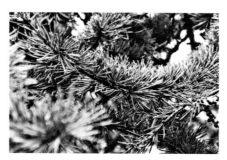

Cedars (*Cedrus*) differ in not having their branches in whorls. The terminal shoots have spirally arranged, solitary needles that are three-sided and pointed at their tips. The side branches have the needles in tufts. The buds are small and oval.

COMPARING THE CONES OF THE PINE FAMILY GENERA

MALE CONES THAT PRODUCE POLLEN

FEMALE CONES THAT CONTAIN THE OVULES, PROTECT DEVELOPING SEEDS, AND HELP DISPERSE THEM

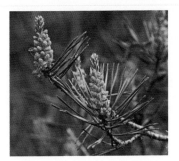

Pines have catkin-like male cones that develop at the base of the current year's growth. The scales produce pollen sacks that shed pollen when ripe. The male cones then die and fall off. The pollen grains have two air sacs attached to help them fly.

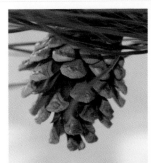

The mature pine cone is woody with broad scales and a knob-like lump (an umbo) on the free end. The seeds have a papery wing that detaches easily.

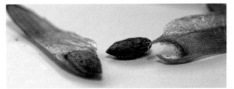

Pine seed showing attachment claws on a papery wing.

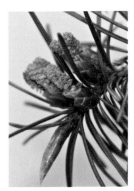

Douglas Fir (*Pseudotsuga*) male cones showing pollen-bearing scales. These cones drop off once the pollen is shed.

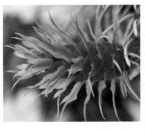

Young female cone. Young female Douglas Fir cones are pink; mature cones have scales with a wide base, no umbos and distinctive long bracts.

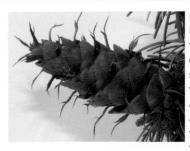

Douglas Fir, mature female cone. The seeds are whitish and firmly attached to their wings.

COMPARING THE CONES OF THE PINE FAMILY GENERA (CONTINUED)

MALE CONES THAT PRODUCE POLLEN	FEMALE CONES THAT CONTAIN THE OVULES, PROTECT DEVELOPING SEEDS, AND HELP DISPERSE THEM

Spruce (*Picea*) (not illustrated)

Female spruce cones are large, with scales that have a broad base but no umbo. The seeds are black and held on a cup on the seed's wing.

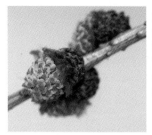

Larch (*Larix*) male cones growing from a side shoot. The scales show obvious yellow pollen sacs.

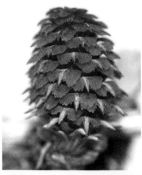

Young female larch cone – these may be green or pink – growing from a side shoot.

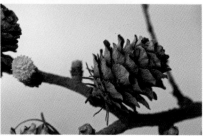

Young and mature female cones. The mature cone is oval and woody with broad-based scales and no umbo. The seeds are whitish and firmly fixed to the seed wing.

Firs (*Abies*)
The male cones have shed pollen and dangle below the branches. The female cones grow upright on top of the branches.

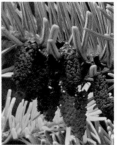

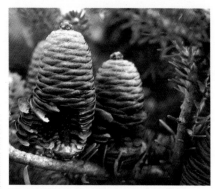

Mature female erect cones of *Abies koreana*, Korean Fir, showing the cone scales falling off with the ripe seeds.

COMPARING THE CONES OF THE PINE FAMILY GENERA. *(CONTINUED)*

MALE CONES THAT PRODUCE POLLEN	FEMALE CONES THAT CONTAIN THE OVULES, PROTECT DEVELOPING SEEDS AND HELP DISPERSE THEM
Hemlock trees (*Tsuga*), not illustrated	The female cones are small, pendulous and terminal, or larger if they are lateral. The cone scales have a narrow base and no umbo. The seeds are brown, and fixed quite well to the seed wing.

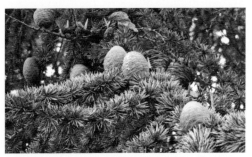

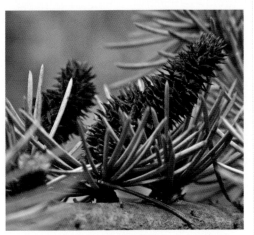

Cedar (*Cedrus*). Old male 5cm cones with dried-out scales after shedding pollen. Unlike other male cones they persist for months before dropping off.

Female cedar cones are terminal on short side shoots. They are oval, erect, with needles at their base, and become reddish in colour when mature; they are the size of a hand grenade, and may cause damage to anything below that they fall on to. They shatter easily into separate broad cone scales (with thick free edges), releasing the pointed winged seeds. (*See* the remains of the cone and seeds below.)

The remains and seeds of a disintegrating old cedar cone.

THE YEW FAMILY (TAXACEAE) AND YEW PLUM PINE FAMILY (PODOCARPACEAE)

These are all evergreen. The Podocarps are of ancient origin and were endemic on the ancient continent of Gondwana, and exist from southern Chile to south-east Asia. Yews occur in temperate zones and are very slow growing. They are similar in that they produce fleshy arils when the seeds are ripe.

COMPARING THE YEW (*TAXUS*) AND *PODOCARPUS*

Yew showing dark green, lanceolate, flattened needles that are arranged alternately and spirally. They look as though they are in two rows, as the leaf stalks are twisted to give a flattened leaf arrangement. These leaf bases are decurrent (extended down the stem), forming distinct ridges. The young twigs are green but the bark is reddish in colour on the trunk and older twigs.

Podocarpus leaves are spirally arranged, bluntly acute and linear, with raised mid-ribs on both sides of the leaves. The leaf stalks also extend down the stem. The bark is scaly and fibrous, and peels in vertical strips. The branches are arranged in pseudowhorls.

Yew male cones are solitary or clustered, and axillary on young branches. They are small and globose, surrounded at the base by inflated bracts, and the cone scales have from two to sixteen pollen sacs. The cones are shed after pollen release. Trees are usually dioecious (single sex), but they can be monoecious with both sexes on the same plant.

Podocarpus male cones are long, thin and catkin-like. The trees are usually dioecious or single sex – that is, male or female.

The female cones of the yew are very small, green and inconspicuous when young, and consist of a couple of ovules surrounded by pairs of opposite bracts. After pollination the seed develops, and ultimately the cone becomes very conspicuous as a pink fleshy aril develops round the upright seed, from the bracts. This aril attracts birds that disperse the seeds.

The female cones of *Podocarpus* are similar in that they consist of two to five fused cone scales, which develop into a colourful, fleshy aril below the seed. The seed usually has an apical ridge.

THE CYPRESS FAMILY (THE CUPRESSACEAE)

This ancient family includes the largest number of genera, and is the third largest conifer family in terms of species. It includes *Thuja, Sequoia* the giant redwood, *Chamaecyparis* the Lawson cypress and *Juniperus* the juniper. They are resinous and aromatic trees and shrubs that are mainly monoecious (with both sexes) although Juniper is dioecious with single sex plants.

Lateral branches are well developed with twigs that are tapering, angled or flattened and covered by scale-like opposite leaves held tightly to the twig, or leaves in whorls of three or four. Their leaves are single and persist several years before being shed with lateral shoots (cladoptiscic), or are shed individually in, for example, juniper, which has two leaf forms – stalkless, needle-like, sharply pointed leaves on immature twigs that are in whorls of three, or scale-like leaves that closely surround mature stems.

The male cones are rounded to oval, with pollen sac bearing scales overlapping. The cones are usually solitary and grow at the end of the branches, or axillary in juniper, or in panicles in, for example, *Sequoia*. They are shed after pollen release each year. The light round pollen is generally not winged – it is light enough to fly in the air to pollinate the female cones.

The female cones are axillary in juniper, but are usually solitary or terminal, or – unusually – in clusters in other genera. The female cones take up to two years before they are shed with short shoots attached, or they may persist indefinitely. The cone scales are usually woody and produce one to twenty seeds, which may have asymmetric wings or none. Juniper has fleshy, dark blue cone scales when ripe to appeal to birds, which distribute the seeds after eating the 'berries'.

Features of the cypress family

Thuja, showing a flattened, frond-like appearance with pairs of scale-like, adpressed leaves that are distinctly ridged. The male cones are terminal and solitary.

Upright, terminal, woody, mature female *Thuja* cone persisting on the tip of a branchlet. Cone scales release small, winged seeds.

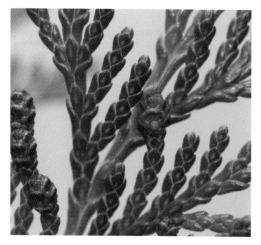

Young female cones on shoot tips.

Chamaecyparis with a flattened, scaly, frond-like appearance. The leaves are scale-like, unridged, and in opposite pairs with an obvious stoma. The male cones are terminal and red.

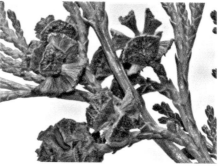

Round, mature *Chamaecyparis* female cones with scales spread apart so as to shed the winged seeds.

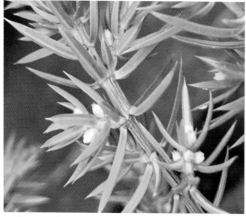

Juniper male cones in the axils of the leaves. Adult sessile (no stalk) leaves grow in alternate rows of three. The leaf bases are decurrent (down the stem).

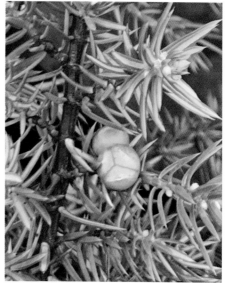

Juniper fleshy female cone. It will turn dark purply-blue when ripe after eighteen months. The cone is axillary, with valvate scales in whorls of three, but only one whorl is fertile. Each fleshy valve contains one seed.

THE ARAUCARIA FAMILY – THE ARAUCARIACEAE

This family is very ancient and reached its zenith in the Jurassic and Cretaceous periods, when they were found all over the world. Now they are reduced to just three genera, found in the Southern hemisphere: *Agathis* (the New Zealand kauri); *Wollemia* (the recently discovered Australian Wollemi pine), which is considered the most primitive; and *Araucaria* (including the monkey puzzles and the Norfolk Island pine).

These are tall, evergreen trees with long trunks, and horizontal branching arranged in whorls of three to seven branches, or with branches alternating in pairs. The spirally arranged leaves are broad or narrow, and have parallel veins.

The male cones are large and drooping, cylindrical and catkin-like. They may take two years to mature. The cone scales are in whorls or spirals, with four to twenty pollen sacs on the lower surface. The pollen is spherical and without wings.

The female cones are large, and round or oval, and are carried erect on short shoots or at the tips of the branches. A single winged seed develops on the upper surface of each scale. Due to the cone size and the height of these trees, falling female cones can cause serious injury!

The Araucaria family

Large, ovate leaves arranged in a flattened spiral: Wollemi pine (*Wollemia*).

Monkey puzzle (*Araucaria*), showing spirally arranged, broad, sharply pointed leaves with parallel veins.

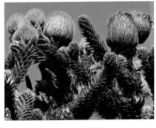

Wollemi pine with cones. Drooping male catkin-like cone in the centre, and large spherical female cones with the cone scales fused at the base and then separate, on the branch tips.

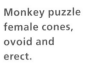

Monkey puzzle female cones, ovoid and erect.

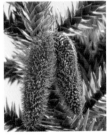

Monkey puzzle male drooping cones below.

THE NON-CONIFER FAMILIES OF NAKED SEEDED GYMNOSPERMS

The Cycadaceae

The Cycadaceae (the sago palms) are very primitive and are not palms! They are of ancient origin and were at their most widespread worldwide in the Jurassic. They are found in the equatorial regions in south-east Asia to Australia, and belong to only one genus, *Cycas*. We used to use these non-palm leaves on Palm Sunday in Hong Kong!

The trunk is usually unbranched and surrounded by persistent bases of the leaf stalks (petioles), where leaves have dropped off.

The leaves are pinnate, tough and thickened and spirally arranged, forming a crown. The leaflets are articulated with only a mid-rib vein. The lower leaflets are reduced to thorn-like protective structures. The scale leaves are persistent and protective.

The plants are dioecious with separate sex plants. The male plants produce a large, apical cone of flattened microsporophylls, with the undersides facing outwards with sporangia that produce male 'pollen' cells that travel (swim) in water. The female plants do not form cones, but produce leaf-like megasporophyll structures, with a linear stalk and an expanded apical lobe that bears the ovules; these sporophylls are loose and surround the apex of the trunk. They grow into pineapple-like cones, as the seeds develop, that disintegrate to release the ripe seeds.

The Cycads

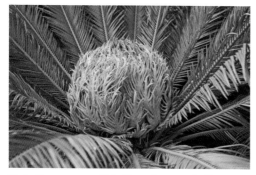

Male *Cycas* cone of flattened sporophylls, at the apex of the trunk and surrounded by the leaves of the crown.

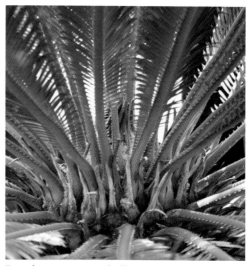

Female megasporophylls surrounding the trunk apex, the apical lobe bearing ovules.

THE GINKGOACEAE FAMILY

This family, of maiden hair trees (*Ginkgo biloba*), has only one living example that is classed as a relict species or living fossil, which survived in glacial refuges in China. It is the oldest seed-bearing plant in the world, from 200 million years ago. The trees are dioecious, either male or female.

The trunk is straight and grey, with irregular furrows in the bark and a distinct crown of branches. The leaves are leathery, and fan-shaped with a central cleft – hence biloba! They have unique venation amongst higher plants, which is dichotomous (veins divide into two).

The leaves arise in clusters from thick, stubby shoots on the branches. In autumn the leaves turn yellow and fall, leaving semi-circular leaf scars.

The male cones arise from short shoots, in whorls, and are catkin-like, without bracts; the sporophylls produce round pollen.

The female seeds arise on long pairs of stems from short shoots. They mature in a year and form a fleshy, orange-yellow seed coat that smells disgusting, but which attracts large birds that eat them and disperse the seeds! So revolting is the smell that the female trees are seldom planted ornamentally. (As a small child I had the misfortune to visit a park in Bologna, Italy, that was full of Ginkgos and had thousands of seeds on the ground. I have never forgotten the stench!)

The Ginkgo

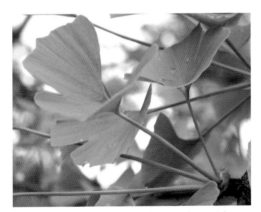

Ginkgo leaf cluster arising from a short side shoot. Note the unique leaf shape.

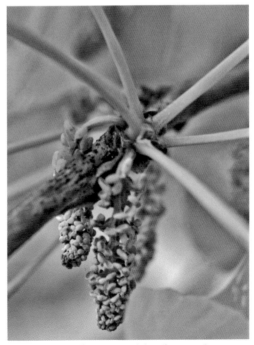

Catkin-like male cones arising from a short shoot on the branch.

In China, pairs of ripening ginkgo seeds with a fleshy covering, turning yellow. The leaves are starting to change colour at the edges.

SUMMARY

In this chapter I have tried to point out the details to look for and to illustrate for each family of the naked seeded plants. Some of the conifers require close investigation to tell one genus and species from another. Looking for the various details will enable you to 'see' and understand more about your plant subject and what to illustrate.

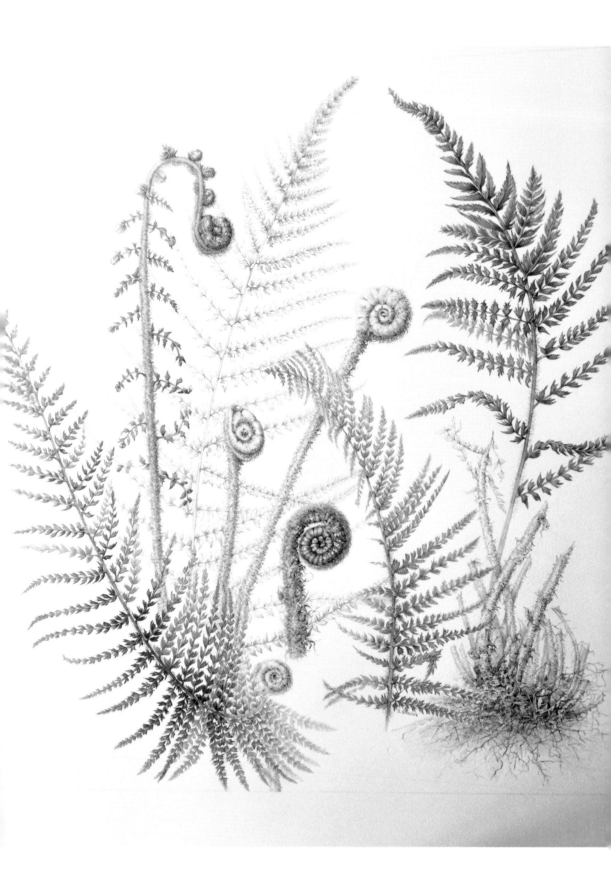

THE FERNS

Ferns are of ancient origin and were most suc-
cessful in the Paleozoic era, when giant ferns
and tree ferns covered the earth; they died out
during the great extinction that killed the
dinosaurs. After that time the dead ferns came
under huge pressure, eventually becoming the
carbon-rich deposits of coal, oil and natural gas,
deposits that we use today.

All these plants also have distinct veins. Evo-
lutionarily they are the first group of vascular
(veined) plants to evolve, and differ from
mosses in that they have distinguishable stems,
roots and leaves. However, the roots are not as
distinct as they are in flowering plants and gym-
nosperms.

Fern plants bear thousands of asexually pro-
duced spores, which disperse and grow into a
small, flat, green feature called a thallus, which
you seldom notice. These thalli bear tiny male
and female sex organs: this is where sexual
reproduction and the mixing of DNA happens.
The resulting fertilised egg grows into a fern
plant, and the thallus disappears. This type of
alternation of two distinct generations occurs in
more 'primitive' lower plants.

THE PTERIDOPHYTES

This chapter details the clubmosses, the horse-
tails and the true ferns (the Pteridophytes).
There are three main groups of ferns:

* The Lycopodiophyta – the clubmosses
* The Sphaeophyta – the horsetails
* The Filicinophyta – the true ferns, which
 spring to mind when you think 'fern'

The Clubmosses

The clubmosses – for example *Lycopodium* and
Selaginella – can be recognised as they have
small and simple leaves that are usually spirally
arranged and densely clothe the stems. These
leaves are often a different shape and size to
those areas of the plant that produce spores.
Fertile (spore-bearing) leaves have the spore
sacs (sporangia) in their axils.

Lycopodium species produce upright stems
that end in club-shaped cones, whilst *Selaginella*
species have specialised spore-bearing areas on
the stems.

All the branches are dichotomous – that is,
split into two (like a tuning fork).

Left: Shirley Slocock, 'Fern'.

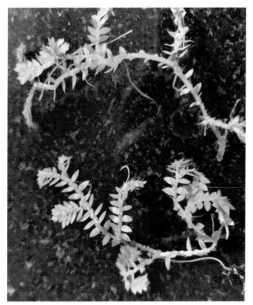

Clubmoss, *Selaginella,* with distinct spirally arranged leaves, distinct stem and proper roots. It has a sprawling habit. Not to be confused with a large moss! Shows dichotomous branching.

Quillworts are also in this group but are very different and are aquatic. I have never found one!

The Horsetails

The horsetails – for example *Equisetum* – have upright hollow stems, whorls of cylindrical branches at the nodes, and small leaves forming a sheath at the nodes. This is the main vegetative part of the horsetail without spore-bearing structures.

The spore-bearing stems are whitish and are quite different. They have a terminal 'cone' with modified leaves that bear sporangia (spore sacs) underneath.

The True Ferns

A huge number of true fern species can com-

The horsetail ferns

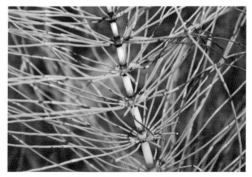

Equisetum telmateia, showing the upright stem, rings of branches at each node, and rings of small leaves forming a basal sheath at each node on the stem and branches.

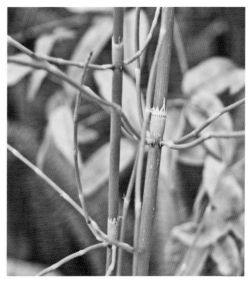

Equisetum, showing the sheath at the node more clearly. An aquatic species in a Chinese lake.

pete with the higher plants – for example bracken, which shades out and kills smaller flowering plants on heathland and is difficult to eradicate.

Ferns are still evolving. The tree ferns have stems more strongly developed than the leaves (fronds), but most more 'modern' ferns have small stems with the leaves being most noticeable.

FERN FEATURES

Fern Leaves

Fern leaves are called fronds and consist of a leaf stalk (rachis) and a leaf blade, which can be entire or divided into pinnae (leaflets), which can be further subdivided into pinnules.

The shapes of the fronds may be ovate, lanceolate, triangular, linear, narrow or oblong. They may have a long frond/leaf stalk (rachis) or a short one, or may not have one at all, with the blade attached directly to the main stem. Everything needs careful observation.

Where the leaf blade is subdivided but doesn't form distinct leaflets, the divisions are called segments (not pinnae). You have to look carefully at how the leaf blades are divided into leaflets and segments, as getting this wrong could lead to the wrong fern being identified! The tip of the leaf blade or pinna may be sharply pointed (acute), obtuse (blunt), recurved, incurved, drawn out to a point (acuminate) or mucronate (ending in a short point).

The base of each pinna, segment or frond may be tapering, asymmetrical, truncate (at right angles to the mid-rib), decurrent (running down the mid-rib or rachis on one side) or attached by its whole width to the mid-rib (adnate).

Fern frond shapes

Asplenium nidus (bird's nest fern), with lanceolate, entire, undivided, infertile fronds with the rachis extended the length of the frond (as a mid-rib). Fronds arise from the short, compact stem.

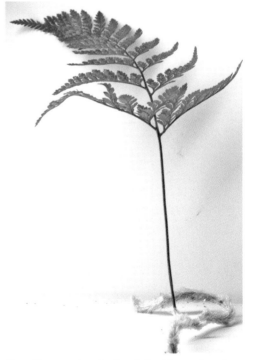

Davallia canariensis, deer's foot fern, showing the creeping underground stem covered in persistent hairs, and the triangular frond divided into pinnae, and these subdivided into pinnules.

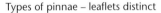

Pinnae and segment shapes

Segments – leaflets not distinct

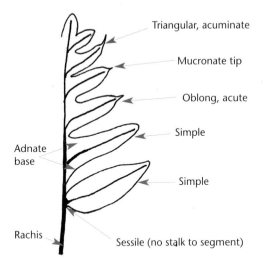

Triangular, acuminate

Mucronate tip

Oblong, acute

Simple

Adnate base

Simple

Rachis

Sessile (no stalk to segment)

Types of pinnae – leaflets distinct

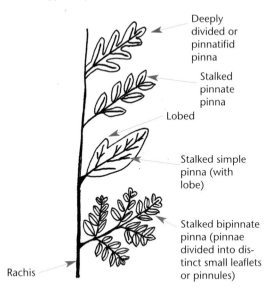

Deeply divided or pinnatifid pinna

Stalked pinnate pinna

Lobed

Stalked simple pinna (with lobe)

Stalked bipinnate pinna (pinnae divided into distinct small leaflets or pinnules)

Rachis

Veining

Asplenium entire (no divisions in the blade) frond showing simple (single) and dichotomous (forked) veins, and a collecting vein at the edge of the blade margin.

Additional detail to be observed is the outer edge (margins) of the leaflets: this can be toothed (large or small), scalloped or curvy edged, smooth, sinuous (curved up and down), reflexed (bent under) or inflexed (bent inwards), or curled. These details may vary in different parts of the frond.

Veins

Veins in the leaves need careful study. They may be simple, dichotomous (forked) or trichotomous (forked into three).

Most veins in fronds are free at the vein tips, but there are exceptions in, for example, bracken, where the veins are linked at the frond margins (like a leaf collecting vein). Putting the frond on a light box or finding an old leaf may help in seeing the veining.

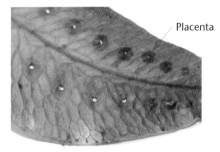

Placenta

Phlebodium aureum showing branched veins and placentas.

Young Fern Fronds

Young fern fronds may protect their tips as they grow, and are furled or coiled forming 'croziers' (like the top of an archbishop's staff). These unfurl as the frond extends.

Scales or Hairs

Scales or hairs need looking out for. Their shape, colour and distribution are distinctive for different ferns. Hairs may be fine, wide, dark, pale or coloured, and densely matted or widely spaced. Added to this, the hairs may be lost on older parts of the plant or may persist.

Male fern, *Dryopteris*, showing the croziers unfurling. Also note the brown hairs or scales on the young rachis/mid-rib.

Scales or hairs

Young hart's tongue fern showing large scales/hairs on the stem and leaf bases, but gradually losing them as the rachis ages and grows longer.

Part of the fishbone fern, *Nephrolepis cordifolia*, showing the thick mat of rusty hairs on the upper surface of the mid-rib/radius.

Large brown scales at the base of an epiphytic fern (*Aglaomorpha fortunei*) on a camphor tree.

Stems

Fern stems are also distinctive in different species. Ferns with trunks (the tree ferns) have tall, vertical stems with a crown of fronds at the top. The trunk is rough with the bases of older, dead fronds.

Tree fern.

Some ferns have short, compact stems at ground level. Fronds arise at the growing tips of these stems – for example Dryopteris, the male fern. Other ferns have branched and creeping stems/rhizomes with small roots on their under surfaces. These ferns are often epiphytes and grow on tree branches and trunks – for example *Phlebodium*, and *Polypodium*.

Stems/rhizomes

Phlebodium aureum, bear's paw fern, showing rhizomes (stems) covered in golden scales/hairs. Aerial fronds grow up from the tips of the rhizomes.

Fertile Fronds and Sori

These fronds are reproductive and usually appear when the plant matures. Fertile fronds produce thousands of very small spores that are distributed by air currents and will eventually grow into fern plants if they land in an auspicious place. They may look different from the main vegetative fronds.

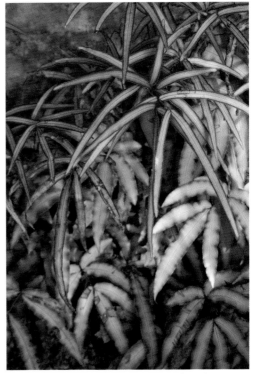

Comparing fertile and vegetative fronds. *Pteris cretica albolineata*, showing fertile and vegetative fronds. The upper fronds are fertile and narrower in shape, and the vegetative fronds are broader and have no thickened edges.

However, in many ferns the younger, vegetative and the older fertile fronds are identical except for spore-producing surfaces (sori) on areas of the underside of a fern frond. You must take care to look out for these and illustrate them, as they are important for distinguishing one fern from another.

Sori are made up of lots of stalked spore-bearing capsules called sporangia, which break open and fling the spores out on to air currents. Young, developing sori are often difficult to spot as they may be covered by a green membrane called an indusium, which protects the sori until they are brown and ripe; then the indusium shrivels to expose the sporangia. In addition, sori are always found along veins to which they are attached by a placenta, which provides water and nutrients, in much the same way as placentas work in animals.

Different arrangements of sori

Polypodium frond from above, showing clear dots (swellings) on the veins, which are placentas. The dark rings of shadow around the placentas are massed sporangia full of spores on the lower surface.

Magnified *Polypodium* frond from below, showing massed sporangia capsules ripe and ready to burst and fling out the spores.

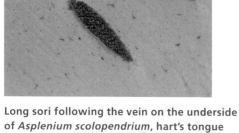

Long sori following the vein on the underside of *Asplenium scolopendrium*, hart's tongue fern. The protective membrane has shrivelled to the edges and the sori have ripened.

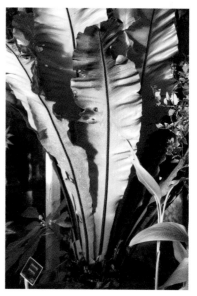

Asplenium nidus showing the fertile area of the frond with ripe brown sori.

Cyrtomium falcatum, Japanese holly fern: the underside of the fertile frond showing the scattered sori, many still with the membranous indusia before they fall off when the spores are ripe.

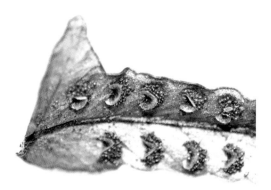

Nephrolepis cordifolia, fishbone or Boston fern, with kidney-shaped sori on the under surface of the frond pinnule. The indusia are shrinking to one side.

Pteris cretica albolineata, showing sori along the edges of the under surface of the frond segments. The indusia have shrunk away to the outer margin. The tips of the segments have no sori.

Adiantum raddianum, maidenhair fern, showing the developing indusia covering the developing sori at the edges of the pinnae.

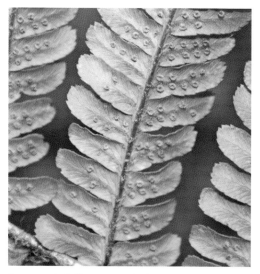

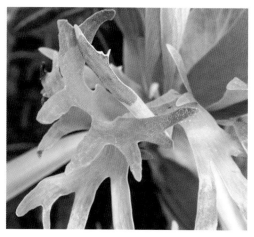

Platycerium, antler fern, with large areas of the underside of the fertile frond tips with massed sporangia (not distinct sori).

Dryopteris felix-mas, male fern, with two rows of sori on the under surface of each pinna on a fertile frond. Indusia are apparent.

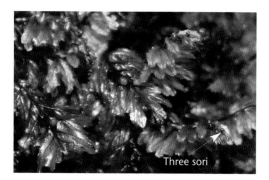

Three sori

Tiny filmy fern, *Hymenophyllum tunbridgensis*, on a moss-covered rock in Scotland. Look closely and you will see round lumps (sori) on the frond surfaces.

SUMMARY

As you may have gathered, illustrating ferns is not for the faint-hearted as there is a huge amount of detail to observe and illustrate, to make your picture accurate and the fern identifiable. I hope this has helped you to look with 'the eye of faith' – knowing what to look for and finding it!

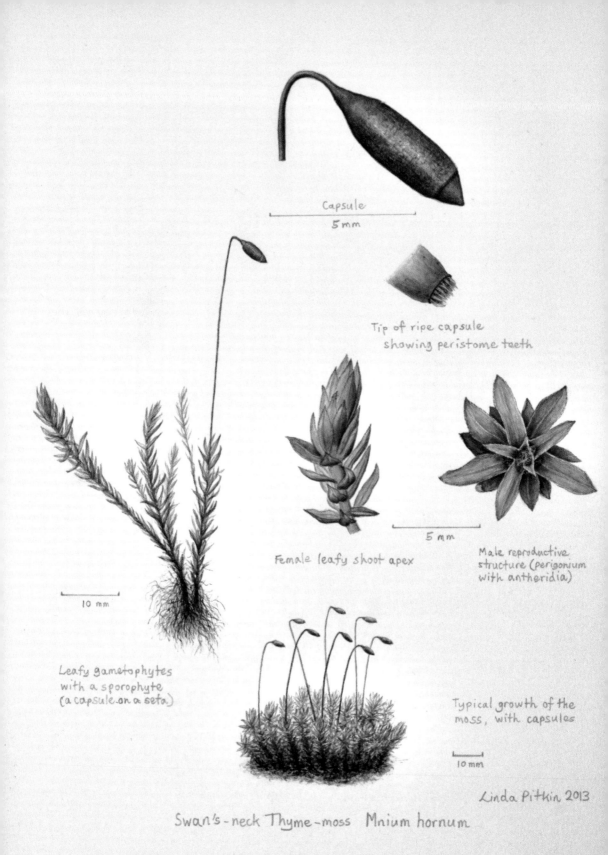

Capsule
5 mm

Tip of ripe capsule
showing peristome teeth

Female leafy shoot apex

5 mm

Male reproductive
structure (perigonium
with antheridia)

10 mm

Leafy gametophytes
with a sporophyte
(a capsule on a seta)

Typical growth of the
moss, with capsules

10 mm

Linda Pitkin 2013

Swan's-neck Thyme-moss Mnium hornum

MOSSES AND LIVERWORTS
(THE BRYOPHYTES)

THE MOSSES

The Bryophytes are the equivalent in plants to Amphibia in animal evolution. Like frogs, they live on land but rely on water for sexual reproduction. They are amazingly resilient to periods of drought, and are amongst the first plants to colonise barren areas. Hence they grow on, for example, crevices on bare rocks, your roof tiles and sand dunes, as well as in damp woodlands, where they can form colonies on the ground and on the tree trunks; and on moorland where they form peat bogs that store carbon, retain water and prevent flooding. They may be generally small in stature, but they are hugely important ecologically.

They are flowerless green plants that do not have roots – just very thin hair-like rhizoids, which anchor them to their substrate and mat together to help water move up the outside of the plant by capillary action. The plants lack developed conducting tissues like xylem or phloem.

Unlike fern plants, but like fern thalli, the bryophyte plants develop very small male and female sex organs and carry out sexual reproduction with sperm-like cells that, once released, swim in a raindrop to the egg cell. The resulting zygote (fertilised egg) is parasitic on the parent plant and grows out into a sporophyte, consisting of a long stalk (a seta) that has a spore-bearing sporangium at the free end. When ripe, the sporangium opens to release the spores, which drift away in the wind to grow into another moss or liverwort plant.

Moss plants have a simple stem, simple spirally arranged leaves, and multicellular rhizoids. Their stalked sporophyte capsules have a protective cap called a calyptra, and a lid over the opening to the spore chamber called an operculum, which falls off exposing the ripe spores and the entrance to the capsule: this is often surrounded by up to two rows of teeth, depending on the species of moss.

Leaf shape, their margins, the presence of a mid-rib or not, and its length, colour and often actual leaf cell shape and structure, can be needed to identify mosses, and are specific to each species of moss.

You will need a 20X hand lens or a good digital magnifier or dissecting microscope and a great deal of patience to observe the features that identify specific mosses if you are illustrating them.

Left: Linda Pitkin, '*Mnium hornum, Swan's Neck Thyme Moss*'.

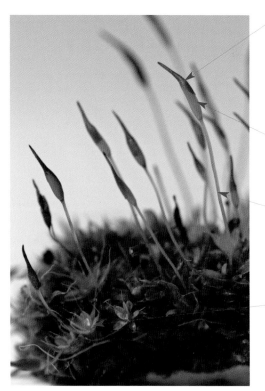

Calyptra or sporangium cap that protects capsule and its lid (operculum) and the developing spores. Drops off when sporangium ripe.

Developing sporangium full of spores.

Stalk or seta of sporophyte, grown from fertilised egg cell, in upright splash cup. e.g. is acrocarpous.

Moss plant upright with leafy splash cup at tip that has sex organs and collects a rain drop. Sexual reproduction happens here!

Tortula muralis, upright acrocarpous moss showing typical moss features.

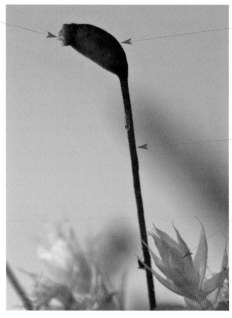

Peristome (opening) surrounded by teeth that help disperse spores.

Sporangium capsule containing spores. Calyptra (cap) and operculum (lid) has dropped off to expose peristome (opening).

Seta or stalk of sporophyte.

Sporophyte growing from side branch leafy splashcup. Moss capsule is pleurocarpous.

Brachythecium rutabulum: branched, pleurocarpous moss showing typical features including peristome teeth on the capsule.

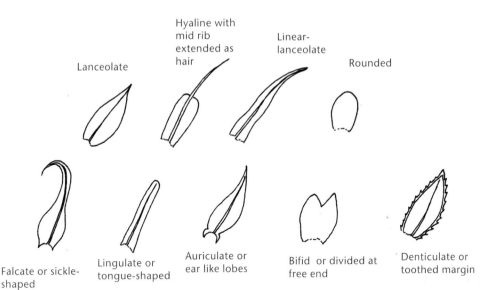

Leaf shapes in mosses.

The examples pictured here will give you some small idea of the range of diagnostic features on moss leaves.

The leaf details of some mosses

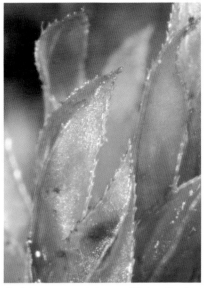

Atrichum angustatum, with toothed margins and toothed mid-rib on the underside of the lanceolate leaf.

Atrichum undulatum, showing linear lanceolate leaves with undulating (wavy), toothed margins and well-defined mid-rib.

Tortula muralis, with a hyaline extension of the mid-ribs forming long hairs.

Sphagnum angustifolium (bog moss), showing fascicles or whorls of pink branches hanging and spreading and forming a capitulum (head) at the top.

Fissidens bryoides, with long, lingulate leaves with borders of clear cells. It has a flattened habit.

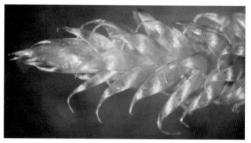

Hypnum cupressiforme, with long, linear, recurved leaves with no border or mid-rib.

Hypnum cupressiforme, showing the coloured splash cups and the difference in vegetative leaves (at the top), and splash cup leaves (below) surrounding the orange-coloured sex organs.

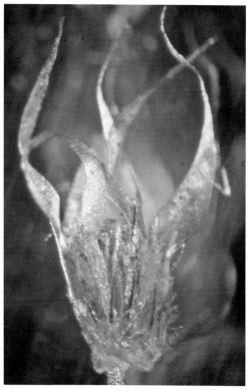

Hypnum cupressiforme: vertical section through a splash cup showing the orange female sex organs and surrounding hairs and leaves.

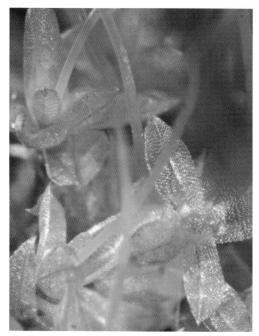

Funaria hygrometrica, with thin, translucent leaves with very large cells, and a mid-rib.

Branching – or lack of it – gives a moss plant its characteristic appearance or habit. Unlike higher plants, the moss branches occur below the leaves. You need to observe this closely, even if you just put in a 'blob' of moss in a painting. The wrong growth habit can ruin your picture, as it will jar the eye (*see* diagram overleaf).

Other moss features to observe include the shape, length and colour of the seta (capsule stalk); the capsule's shape, colour and how it is attached to the seta; the shape and colour of the calyptra (cap); and the peristome (opening to the capsule) – has it got no teeth, or is it made up of one or two rings of teeth? The outer teeth are stiffer, and there may be up to sixteen inner teeth. Also look to see if there are hairs between the two rings of teeth.

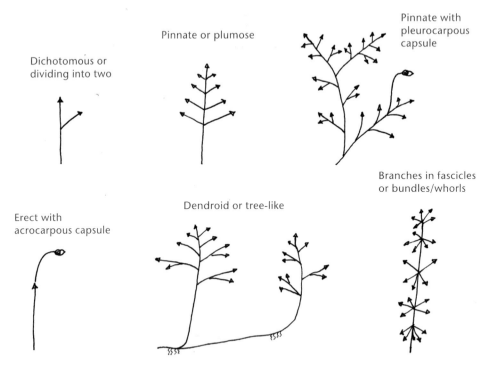

Dichotomous or
dividing into two

Pinnate or plumose

Pinnate with
pleurocarpous
capsule

Erect with
acrocarpous capsule

Dendroid or tree-like

Branches in fascicles
or bundles/whorls

The branching habits of mosses.

Capsule and peristome details. The examples shown
here should give you some idea of what to look for.

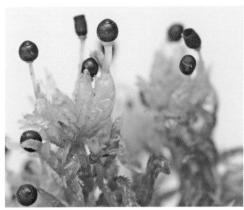

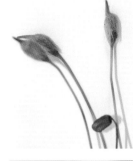

*Polytrichum
commune* capsules,
with pointed,
shaggy, hairy
calyptras (caps).
The older capsule
looks angular with
no peristome teeth.
There is a
membrane across
the entrance, and
slits at the margin
to let out the
spores.

Sphagnum, with round capsules and
operculum (lid) showing, and the calyptra
absent. Sporangia that have shed their spores
look urn shaped. These are unusual in mosses
as they are transient, with fleshy setae (stalks).

Grimmia pulvinata, with a single row of peristome teeth.

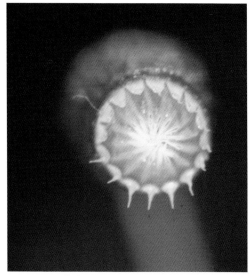

Bryum capillare capsule opening, with two rows of peristome teeth.

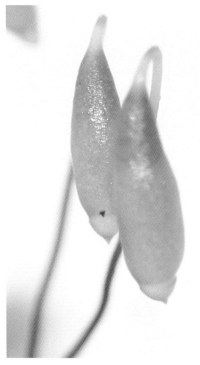

Young capsules of *Bryum capillare* with no calyptra but showing the conical operculum covering the peristome.

Tortula muralis: capsule with long, twisted peristome teeth.

There is plenty to look out for and to observe if you intend to make a serious attempt to illustrate different moss species.

THE LIVERWORTS

In most liverworts the spores are mixed with long, narrow, hair-like elaters that twist as they dry and flick out the spores. The different liverworts have elaters with different, species-specific bands of thickening.

Thalloid liverworts are dorso-ventrally flattened, lobed and leafless, and divide into two equal branches at their tips (dichotomous branching). The thallus often has a mid-rib, and many have pores leading to air-filled chambers.

Some species of thalloid liverwort may also have circular cup-shaped outgrowths that look like mini birds' nests. These are gemmae cups, which have small packets of cells that bounce out in raindrops and grow into new liverwort plants. This is asexual reproduction, which is quicker in good growing conditions than more complex sexual reproduction.

Leafy liverworts are flattened in habit and are the most common of the liverworts, but they are small and more difficult to notice. They have a simple stem and three rows of leaves – two upper dorsal leaves and a row of smaller leaves on the ventral (lower) surface. The leaves are often bi-lobed.

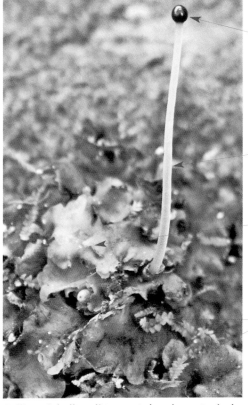

Sporangium containing spores. It is usually round or spherical and splits open by valves to expose the spores. No cap (calyptra) present

Seta (stalk) normally delicate and colourless

Dorso-ventrally flattened thallus (plant), lobed like liver!

Leafy liverwort plants

Pellia epiphylla, a liverwort showing a typical flat thallus (plant), with short-lived sporophyte growing from a fertilized egg cell on the thallus.

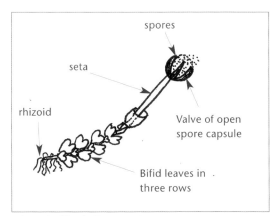

A typical leafy liverwort.

Liverworts

Lophocolea bidentata, with bifid translucent leaves. A leafy liverwort.

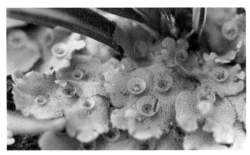

Marchantia gemmae cups with 'packets' of cells, and air pores on the thallus.

Riccardia latifrons thallus, a typical thalloid liverwort.

You will find some other odd-looking features in, for example, *Marchantia*, a thalloid liverwort that has its sex organs on the underside of an aerial structure that looks like the spokes of an umbrella.

However, this chapter should help you to observe these varied and normally overlooked plants that make up the Bryophyta.

When studying and collecting bryophytes, remember to note the place where you found it, its habitat and what it grows on – for example the tree trunk, the soil type. This is all useful information when trying to identify them.

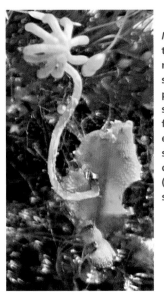

Marchantia thallus and reproductive structure that produces a sporophyte from a fertilised egg cell. The sporophyte capsule (sporangium) sheds spores.

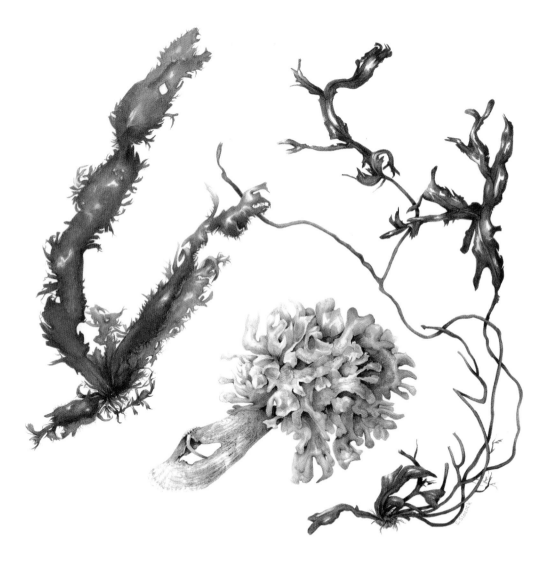

THE SEAWEEDS (MARINE ALGAE)

The algae include all the seaweeds, the 'pond slimes', algal blooms, thread-like pond blanket weeds, small single-celled terrestrial algae such as *Pleurococcus* on tree trunks, and those associated symbiotically with fungi to form lichens. They are a diverse group of organisms that are incredibly resilient.

All algae are either autotrophic (self-feeding) – being photosynthetic, because they make their food from carbon dioxide, water and light energy in the presence of chlorophyll (green pigment) – or heterotrophic (using another source of energy). They may be single celled or multicellular, and they live in a wide range of habitats in saline marine habitats, freshwater or various terrestrial habitats.

Here I will deal with the large, multicellular algae (seaweeds) that inhabit marine environments at depths where light can penetrate. They are primitive in evolutionary terms and lack roots, stems and leaves, and have no conducting tissues. They are, however, lovely to illustrate and to paint, with a huge variety of shapes and forms. In addition you can have great fun searching for them at the seaside!

SEAWEED 'PLANTS'

The seaweed plants are made up of a plant body called a thallus, which may be filamentous (stringy), flattened or rather formless. Those that grow attached to rocks – for example bladderwrack or kelp – have a swollen basal structure called a holdfast (branched, button- or

The disc holdfasts can be seen at the base of the stipe.

Left: Shirley Slocock, 'Seaweeds'.

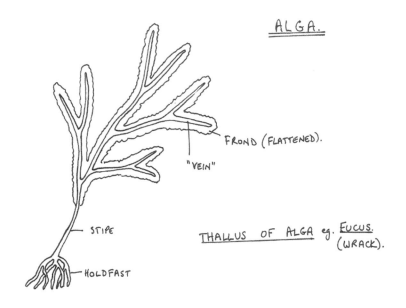

A typical seaweed.

disc-like), to hold the seaweed to a rock.

If the seaweed is stalked, the stalk is called a stipe. The main body is the thallus and may have slightly thickened areas of cells where you would expect a mid-rib to be. Some seaweeds, for example bladderwrack, also have air bladders to enable the fronds to float up towards the source of light.

REPRODUCTION

Seaweeds reproduce asexually when bits of the thallus grow into new 'plants'. However, many seaweeds – for example *Fucus* – reproduce sexually by means of male cells (sperm-like) and female egg cells that are produced in cavities in the swollen parts or tips of the thallus, called conceptacles. When the sex cells are ripe they emerge through small pores called ostioles into the sea water, where fertilisation takes place. The resulting fertilised egg cell then attaches to

a substrate and grows into a new thallus. (The massed emerging sex cells may be coloured – such as orange – and are often slimy.)

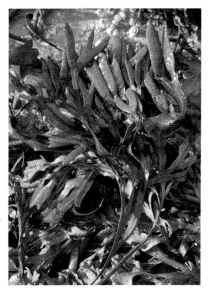

Fucus spiralis, spiral wrack; the swollen conceptacles can be seen at the branch tips. Note the twisted habit. It is a brown seaweed.

ZONATION

Kelp are amongst the largest seaweeds and live below the low tide mark. Most other seaweeds occupy the intertidal zone on rocky shores and exhibit distinct zonation, as their habitat (the area of the intertidal shore) is defined by the length of time a species is uncovered by seawater each day.

There are three main groups of seaweeds, depending on their colour.

The Chlorophyta are green (due to obvious green chlorophyll pigment) – for example sea lettuce. These are the simplest algae.

The Rhodophyta are red (due to the predominance of red pigment masking the chlorophyll) – for example *Corallina*. They range in colour from red to pinkish to maroon to browny red.

They branch in an irregular way with roughly pyramidal outlines. The male reproductive structures are urn-shaped, and the female structures are ovoid; they are borne on the top branches. They grow on rocks.

Ulva lactuca, sea lettuce. It has a very thin thallus with no mid-rib. Older fronds typically have holes

Young sea lettuce.

Old sea lettuce.

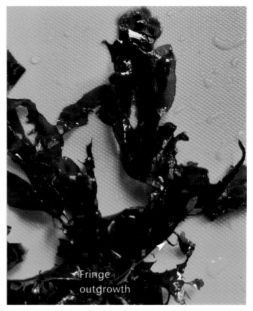

Fringe outgrowth

Calliblepharis ciliate, red fringed weed, with elongated oval fronds fringed by simple outgrowths – this can be profuse, or in this case occasional.

Osmundea osmunda, royal fern weed (it looks brown but is browny red)

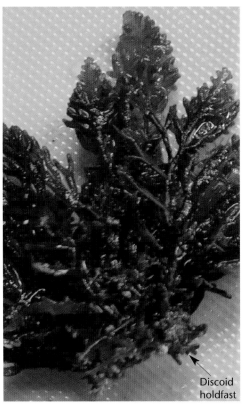

Ovoid
female sex
organ

Discoid
holdfast

Showing holdfast and 'plant' habit.

Ovoid female reproductive structures can be
seen at the top of the branching thallus.

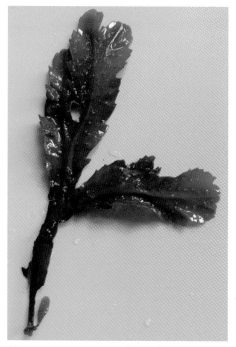

Fucus serratus, serrated wrack.

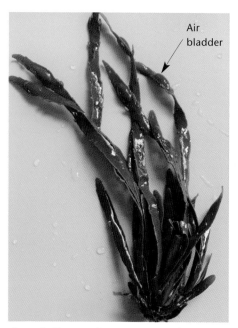

Ascophyllum nodosum, egg wrack.

The Phaeophyta are brown (due to brown pigments masking the chlorophyll). They range in colour from brown to olive brown.

This group of algae are the most complex. Although the thallus may look as though it has a mid-rib, in fact this is just a thickened area without any defined structure – for example *Fucus* (wrack), the kelps, etc.

The fronds are flattened with saw-toothed edges and a disc-shaped holdfast. There is an obvious mid-rib, with thick, tough fronds. One bladder a year is produced on 1 cm wide frond, and a disc-shaped holdfast anchors it.

Some seaweeds have minute colonies of small animals living on them. These are usually bryozoans. Some stick out like zig-zag stiff hairs, others form patches on the fronds.

The Field Studies Council have produced some good keys to help identify seaweed, and there are many guides available. *Seaweeds of Britain and Ireland* by Bunker, Brodie, Maggs and Bunker, ISBN 978-0-9955673-3-7, includes distribution maps, clear descriptions and photographs.

Bryozoan (animals) – white calcareous colonies on *Calliblepharis*; other types of bryozoa protrude from the frond and are usually thin, wiry, and zig-zag in shape.

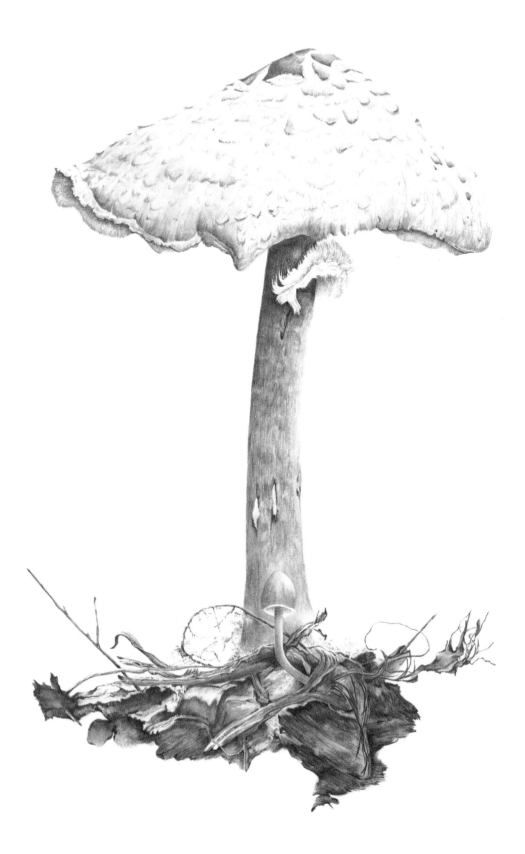

THE CAP AND OTHER LARGE FUNGI

Fungi are no longer classified as plants as they have no chlorophyll and so cannot make their own food by photosynthesis. They are either parasitic (they feed on another living organism) or saprophytic (they feed on dead organisms). Saprophytes are very important as they digest and cause dead organisms to decay. This is a two-edged sword, as 'good decay' gets rid of dead plants and animal material, but 'bad decay' ruins crops, foodstuffs and many other materials. Fungi adapt to living on most things in time, even glass.

Fungi also differ in the structure of their cell walls, which are of chitin (an animal polysaccharide) not cellulose, like plants, and their food storage carbohydrate is glycogen (found in animals), instead of starch. However, they are like plants in that their cells are enclosed in cell walls.

Most fungi are made up of filamentous, thread-like hyphae. The main fungus 'plant' is called a mycelium, which grows through its

YEAST CELLS

Yeast cells are different in that they are rounded, single, cell-like, microscopic organisms. They are important in brewing and baking, and do not form a mycelium. These and moulds, mildews and some parasitic fungi are not going to be dealt with here.

chosen food.

The stalked toadstools growing out of the mycelium are the fungus's reproductive structures, or fructifications, which are also made up of tightly packed hyphae. These fungus fruiting bodies produce spores that will grow more fungi if they land on a suitable substrate. They are usually the only easily observable features of the fungal 'plant'. Fungi with these structures are called the 'true fungi' and are divided into two main groups depending on how the spores are produced.

Cap fungus, showing white thread-like hyphae embedded in decaying leaves (substrate) at its base. *Mycena galopus*, milk drop mycena.

Left: Helen Cavalli, 'Parasol Mushroom, *Macrolepiota procera*'.

THE BASIDIOMYCETES

The Basidiomycetes group includes most of the fungal fructifications that you can see with the naked eye. They produce specialised cells called basidia, which produce thousands of microscopic basidiospores. The fruiting bodies or fructifications are designed variously, to help each fungus distribute its spores. There are three main groups of Basidiomycetes.

The Homobasidiomycetes or Cap Fungi

This group includes mushrooms, toadstools and bracket fungi.

The cap develops spore-producing structures on its underside, such as gills, veins, tubes, spines or teeth. All the different shapes and forms of these cap fungi have evolved to shed their spores efficiently into air currents that disperse the spores (*see* diagram opposite).

The *gill attachments* to the stalk or stipe vary greatly and need careful observation. They grow from the under edge of the cap margin to their inner attachments to the stipe. These vary in several ways (*see* diagram opposite).

Observe the *cap margins*:

* Are the cap-free margins regular, wavy, or turned up, in or down?
* Are the cap margins sharp edged or rounded?
* Can you peel the skin off the cap?
* What colour is the exposed flesh, and does it discolour in time? Does it produce a milky latex?

Scale left on cap from universal veil that enclosed the whole developing fructification

Remains of partial veil covering the gills (gills exposed on left of cap as veil disintegrates.

Annulus or ring left by partial veil

Stipe

Volva (cup at base) remnant of universal veil

Bulbous base of stipe with warty remains of universal veil

Typical parts of a perfect basidiomycete fructification.

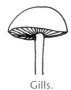
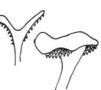
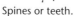
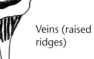

Gills.

Spines or teeth.

Veins (raised ridges)

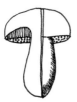

Tubes that look like sponge with pores from underneath.

Types of spore-producing structures in cap fungi.

Adnate or closely attached

Free

Withdrawing from the stipe

Notched end or emarginated

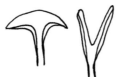
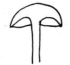
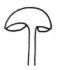
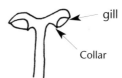

gill

Collar

Exended down stipe or decurrent

Gills attached to a collar

Gill attachments to the stipe.

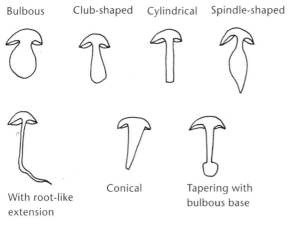

Bulbous Club-shaped Cylindrical Spindle-shaped

With root-like
extension
Conical
Tapering with
bulbous base

The shape of the stipe or stalk.

Observe the *spore-bearing surfaces:*

* Are the gills soft, flexible, hard or brittle? What colour are the gills when young and mature? Do the gills turn black and inky as they age, as in ink caps?
* If there are teeth (not gills), are they short or long, sharp or blunt, thick, thin, scattered, brittle, flexible? What colour are they?

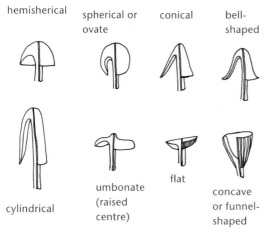

hemisherical spherical or conical bell-
 ovate shaped

cylindrical umbonate flat concave
 (raised or funnel-
 centre) shaped

Cap shapes to note.

Helen Cavalli, 'Ink Cap, *Coprinopsis atramentaria*'.

* If there are veins, are they single, branched or forming a network? Are they thin or thick, dense or widespread?
* If there are tubes, what colour are they in young and mature fungi? Do they change colour when bruised? (My sister ended up in hospital without taking note of this feature!)
* What size and shape are the pores?

Observe the *cap shape*, and other features. The *cap surface* also varies, and a minor difference can mean it is a different species. Is it smooth, dimpled, wrinkled, rough, bare, hairy, velvety, fibrous, covered in scales, sticky, dull, dry, shiny or streaked? Or combinations of these characteristics?

Note the *cap colour*, when wet and dry. What

is the *size range* of the caps of each different type of mushroom/toadstool?

Stipe shape is very important. The difference between a field mushroom and a death cap stalk can mean an enjoyable breakfast or death! Death cap has a volva or cup-shaped membrane at the base (*see* picture on page 132). In fact, any fungus with a volva is to be avoided.

The surface of the stipe also needs noting. Is it smooth, grooved or ribbed, dimpled, fibrous, scaly, slimy, sticky, shiny, dull?

What is the colour of the stipe? This may

change as the fungus ages, so note all ages if possible.

Is the stipe hollow, solid or compartmented?

Is there an annulus (membranous ring) below the cap? This is also characteristic for a fungus. Is it wide, narrow, wavy, ridged, ragged, absent or loosely attached?

Once armed with all your observations, you are in a good position to illustrate the mushroom, toadstool or bracket fungus. You will also be able to identify it more accurately – especially if foraging!

Bracket fungi

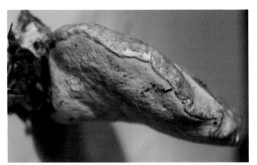

The Bracket fungus grows only on birch tree trunks – the birch polypore. It has white pores below the tough brownish cap.

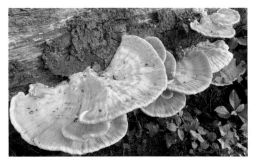

Laetiporus sulphureus, 'Chicken of the woods', or sulphur shelf fungus, on yew.

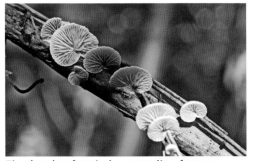

Tiny bracket fungi, the oysterling fungus, *Crepidotus variabilis*, with gills of varying length, some not reaching the point of attachment.

BRACKET FUNGI

When collecting bracket fungi you should note what tree it is on, as they can be very specific. Bracket fungi lack stipes, and the cap grows out of the tree trunk. Also note the habitat in which your fungus is growing, whether a field, a pine wood, a deciduous wood. This, too, will help identification.

The Gasteromyces

The Gasteromyces include many strange, distinctive fungal forms, where the basidia (spore-producing cells) are enclosed inside the fungus – for example bird's nest fungus, the stinkhorns, the earthstars and the puffballs. Note what they are growing on and their habitat, as well as their various attributes when young and mature.

The puffballs

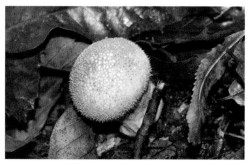

Common puffball, solid when young, and soft as the spores mature. It then splits open to release a 'puff', or cloud of spores when disturbed.

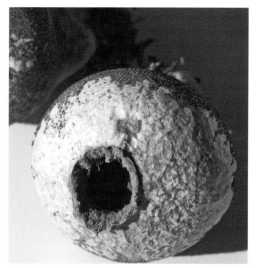

Another species of puffball showing the operculum (hole) that has opened to reveal the olive spore mass.

The Heterobasidiomycetes

Jelly fungi

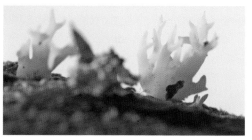

Jelly antler fungus, *Calocera viscosa*, simply branched and growing on wood.

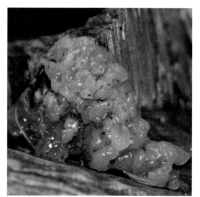

Exidia alba, grey jelly fungus on a dead tree stump.

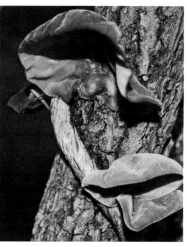

Auricularia auricula-judae, 'Jew's ear' fungus growing on an elder tree. Note the slightly hairy-looking upper surface and shiny lower surface. It is frequently eaten in Asia, and sold dry.

The Heterobasidiomycetes include the jelly fungi. The basidia (sporing cells) are formed on the outside of the fruiting body. These fungi are gelatinous when wet, and very hard and shrunken when dry.

Some fungi with basidia sporing cells do not conform to an expected shape.

The odd-shaped basidiomycete fungi

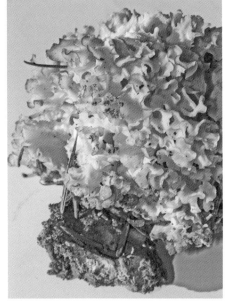

Sparassis crispus, the wood cauliflower, which is parasitic on pine stumps.

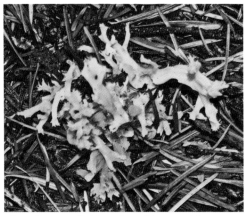

Clavulina coralloides, the white coral fungus growing on rotting pine needles.

ASCOMYCETES

The Ascomycetes are fungi that produce ascospores in specialised cells called asci – they are different in structure to the basidia, where the spores are formed on projections from their free ends. These ascomycete fungi are divided into two main groups: discomycetes and pyrenomycetes.

Discomycetes

The Discomycetes include the morels, cup fungi (*Peziza*) and truffles. In these fungi the asci form a layer on the surface. They are the most commonly known due to their culinary desirability.

Pyrenomycetes

The Pyrenomycetes include the cramp balls, dead man's finger fungi, coral spot fungi, the stag's horn fungus and others. Here the asci are found lining sunken structures that open to the surface through a hole called an ostiole. When the ascospores are shed they are often of a different colour.

Ascomycete fructifications

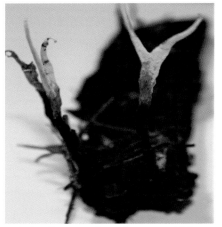

Xylaria, the stag's horn fungus, which emerges as tough, stringy, black structures that turn white where the white ascospores are released.

Daldinia concentrica, cramp balls: these are hard fungi that people used to manipulate to rid themselves of cramp! You can see white dots on the right-hand one where the ostioles (pores) are.

Daldinia concentrica: asci form successive layers, which can be seen when the cramp ball is broken open.

SUMMARY

There are lots of exciting fungi out there in all shapes and sizes just waiting to be painted. Have fun discovering them.

I have not recommended a particular book as there is such a plethora of them on fungi. Just trust your observations and instincts, and look in several books if you are foraging. The descriptions vary and can mean the difference between a nasty death or life. Not for nothing did the ancients put a sample on the window ledge, to let others know what they had eaten if they died!

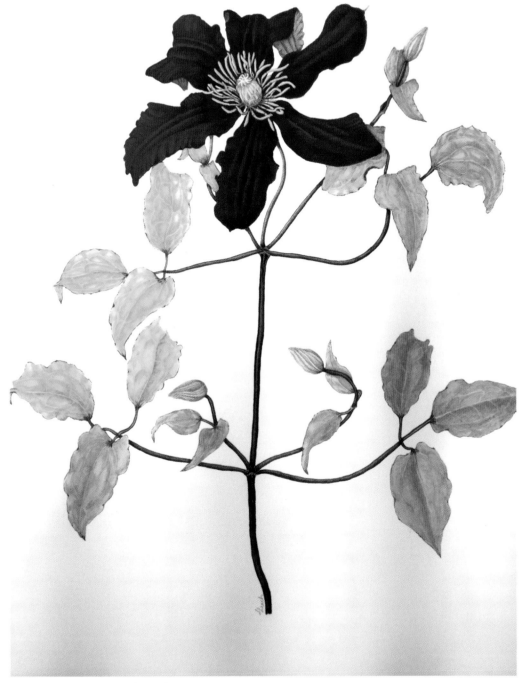

Clematis Niobe - Lizabeth Leech.

INDEX